Lise Herzog

365 days of drawing

FIREFLY BOOKS

A FIREFLY BOOK

Published by Firefly Books Ltd. 2020
English translation © Firefly Books Ltd. 2020
Text and illustrations © Lise Herzog 2019
© First published in French by Mango, Paris, France 2019
as *365 jours de dessin* (9782317022166)

First printing

Library of Congress Control Number: 2020940234

Library and Archives Canada Cataloguing in Publication
Title: 365 days of drawing / Lise Herzog.
Other titles: 365 jours de dessin. English |
 Three hundred and sixty-five days of drawing
Names: Herzog, Lise, author.
Description: Translation of: 365 jours de dessin.
Identifiers: Canadiana 2020027242X | ISBN 9780228102601 (hardcover)
Subjects: LCSH: Drawing—Study and teaching. | LCSH: Drawing—Technique.
Classification: LCC NC650 .H4713 2020 | DDC 741.2—dc23

Published in the United States by
Firefly Books (U.S.) Inc.
P.O. Box 1338, Ellicott Station
Buffalo, New York 14205

Published in Canada by
Firefly Books Ltd.
50 Staples Avenue, Unit 1
Richmond Hill, Ontario L4B 0A7

Translation: Claudine Mersereau

Printed in China

Canada

We acknowledge the financial support
of the Government of Canada.

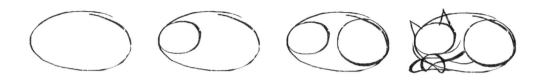

Sleeping Cat

A cat is a very flexible animal, able to roll itself up completely. To draw a cat in a ball, superimpose the rounded shapes then add small details: nose, whiskers, ears, tail...

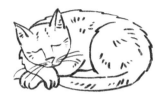

1st **day**

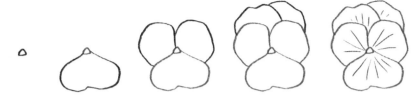

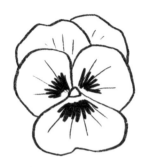

Pansy

To draw a pansy, start with the big upside-down heart-shaped petal at the lower front of the flower. Then, successively add the other petals, and finish by adding small details.

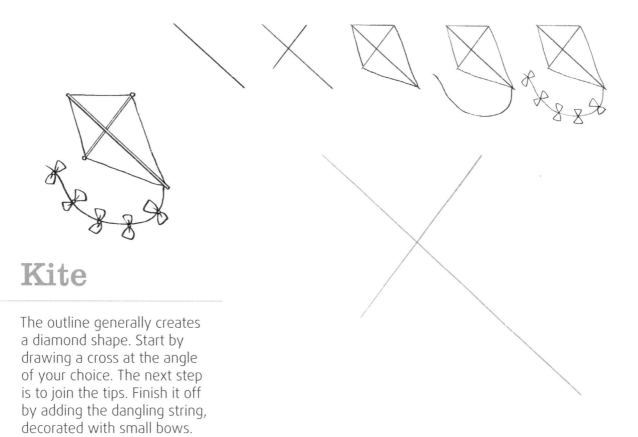

Kite

The outline generally creates a diamond shape. Start by drawing a cross at the angle of your choice. The next step is to join the tips. Finish it off by adding the dangling string, decorated with small bows.

3rd **day**

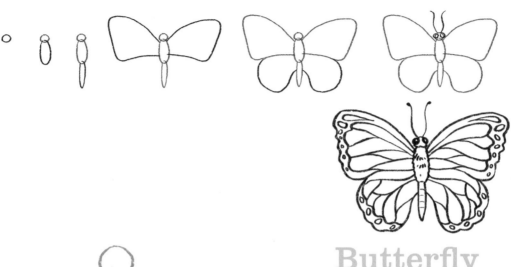

Butterfly

In perfect symmetry, the butterfly unfolds shapes and patterns on both sides of its body. The shape of the wings can vary, but the top often forms an angle. The variety of patterns is infinite...

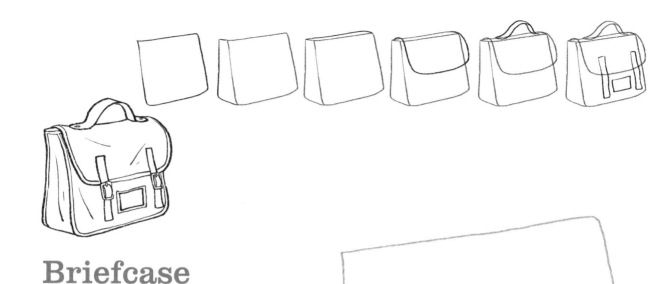

Briefcase

The first few lines of the drawing usually look like a rectangle that is transformed by adding details. If you draw this object in perspective, make sure to angle the horizontal lines a bit, by directing them towards each other at the back.

5th **day**

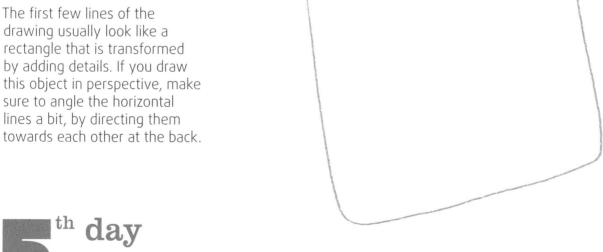

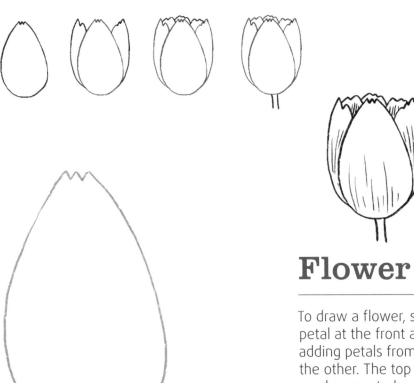

Flower

To draw a flower, start with the petal at the front and continue adding petals from one side to the other. The top of the petals can be serrated.

6th **day**

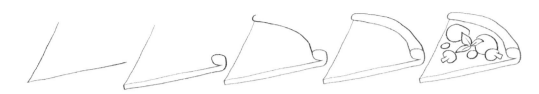

Slice of pizza

A slice of pizza, pie, or cake first looks like a triangle. Continue by thickening the starting shape and closing it up by rounding it off. The last step is to add the toppings.

7th **day**

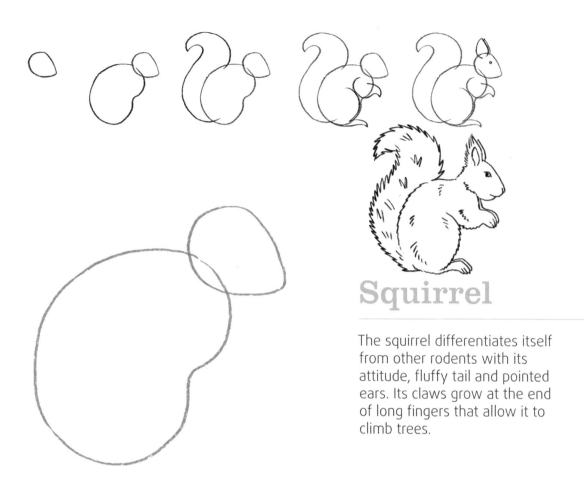

Squirrel

The squirrel differentiates itself from other rodents with its attitude, fluffy tail and pointed ears. Its claws grow at the end of long fingers that allow it to climb trees.

8th **day**

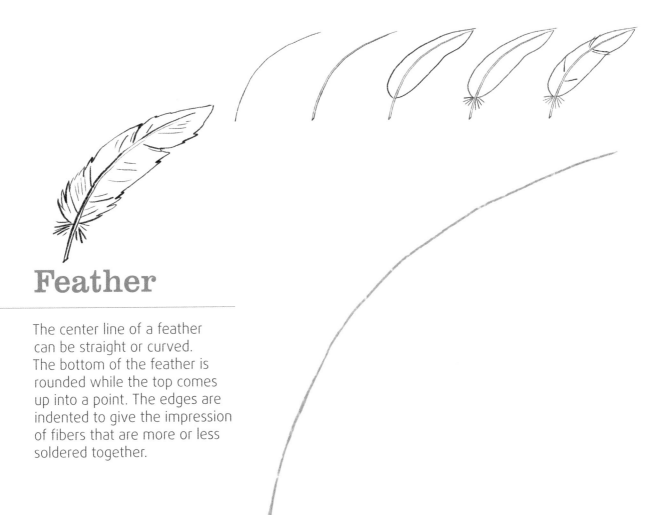

Feather

The center line of a feather can be straight or curved. The bottom of the feather is rounded while the top comes up into a point. The edges are indented to give the impression of fibers that are more or less soldered together.

9th **day**

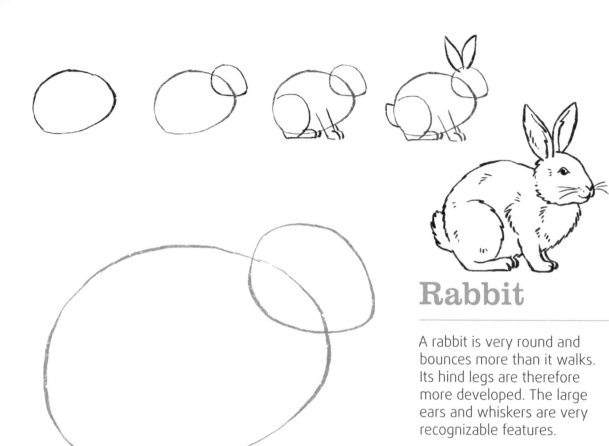

Rabbit

A rabbit is very round and bounces more than it walks. Its hind legs are therefore more developed. The large ears and whiskers are very recognizable features.

10th **day**

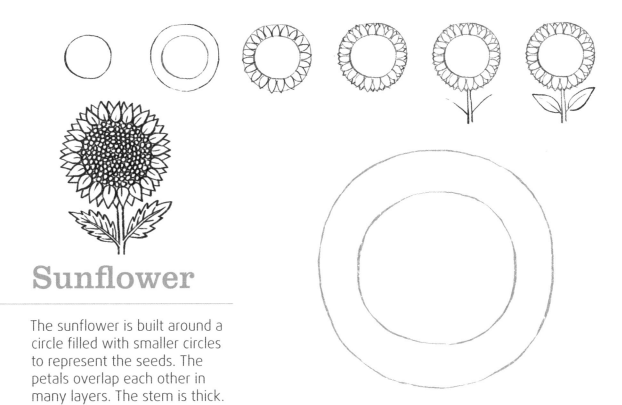

Sunflower

The sunflower is built around a circle filled with smaller circles to represent the seeds. The petals overlap each other in many layers. The stem is thick.

 th day

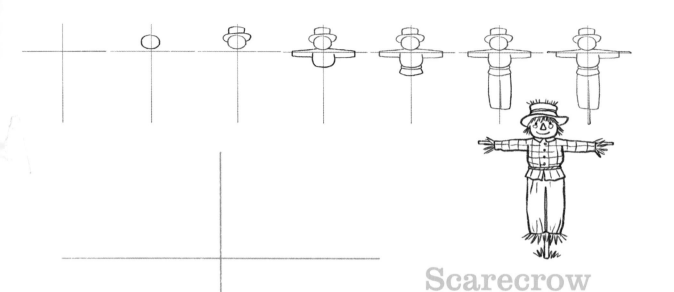

Scarecrow

A scarecrow vaguely resembles human proportions. It is most often represented with arms spread out like a cross. It's the clothing, clown-like face and straw hands and feet, that make it so easily recognizable.

12th **day**

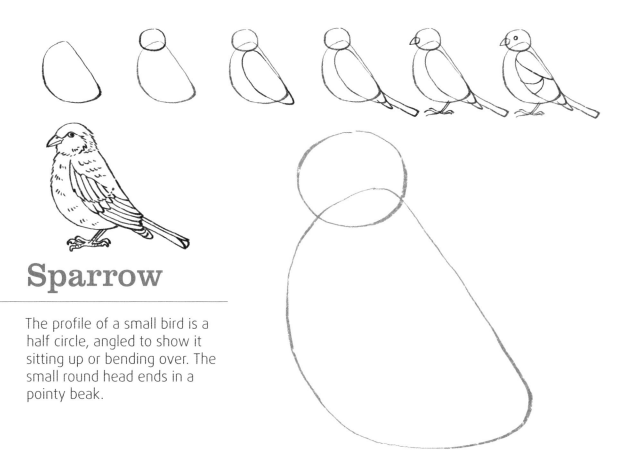

Sparrow

The profile of a small bird is a half circle, angled to show it sitting up or bending over. The small round head ends in a pointy beak.

13ᵗʰ day

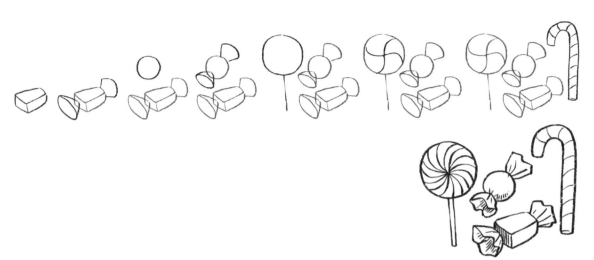

Candy

Candy generally has a base shape that's round or rectangular, and is softened with shading. The next step is to add small cones on either side to represent the plastic wrapper.

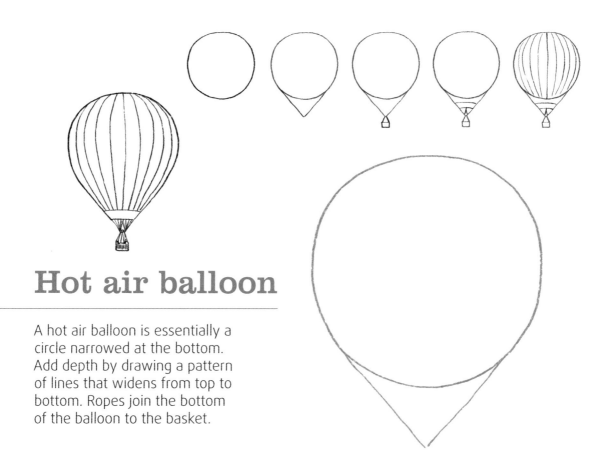

Hot air balloon

A hot air balloon is essentially a circle narrowed at the bottom. Add depth by drawing a pattern of lines that widens from top to bottom. Ropes join the bottom of the balloon to the basket.

15th day

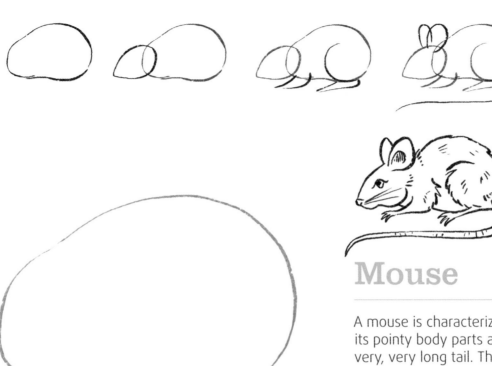

Mouse

A mouse is characterized by its pointy body parts and its very, very long tail. The body is larger at the rear. Its rounded ears are quite big and its paws are clawed.

16th day

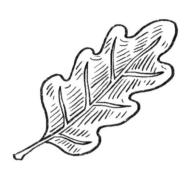

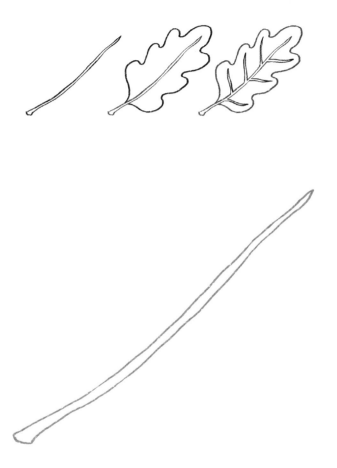

Oak leaf

The leaf of a classic oak tree has a very straight stem. Draw the leaf outline using deep rounded and indented points. Then add the veins.

17 day

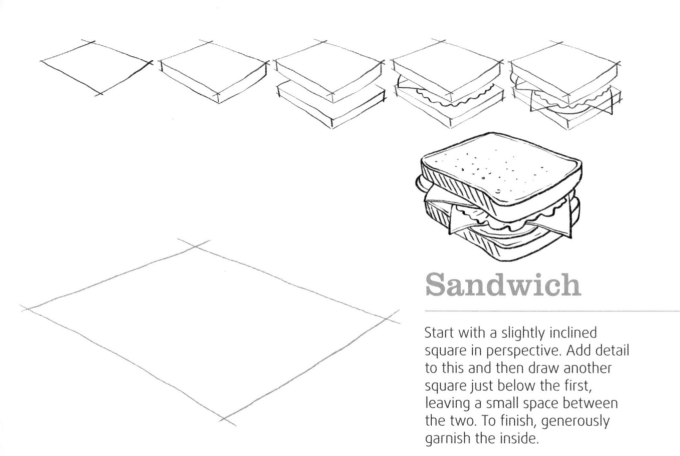

Sandwich

Start with a slightly inclined square in perspective. Add detail to this and then draw another square just below the first, leaving a small space between the two. To finish, generously garnish the inside.

18th **day**

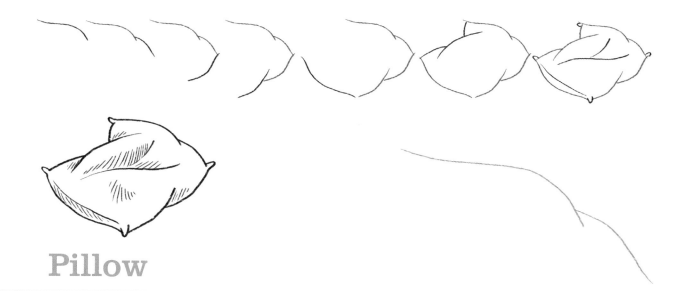

Pillow

A pillow is a dented rectangle with curved lines to create bumps and folds which make it appear soft. To show detail, add a bit of shadowing.

th day

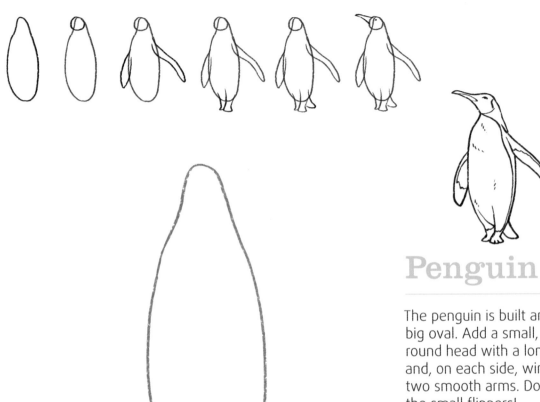

Penguin

The penguin is built around a big oval. Add a small, extended round head with a long beak and, on each side, wings like two smooth arms. Don't forget the small flippers!

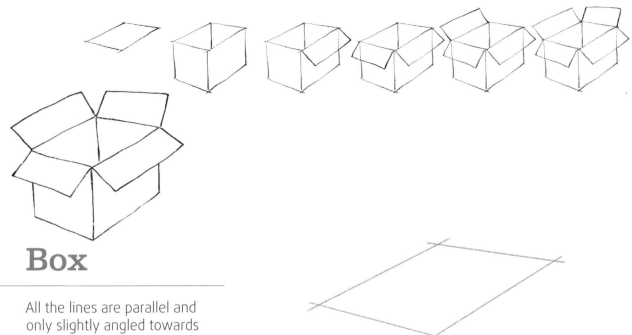

Box

All the lines are parallel and only slightly angled towards a far-off point on the horizon. Start with a rectangle for the opening of the box. Give it some depth using lines to create the inside and add the flaps.

21st **day**

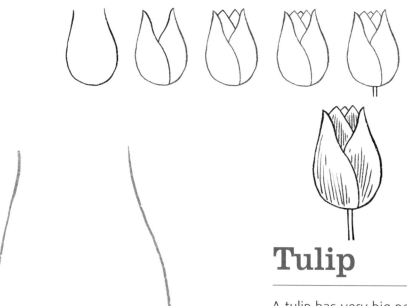

Tulip

A tulip has very big petals in the shape of a goblet. Start by drawing a "U" shape then split this shape to draw the two front petals. Finish it off by adding a few petals to the center.

22nd **day**

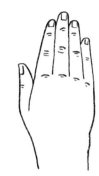

Top
of the hand

Start with a rounded square to create the palm. Add the wrist, the base of the thumb and small squares to form the first segments of the fingers. Follow up with the other finger segments, making sure to add the knuckle lines.

23rd day

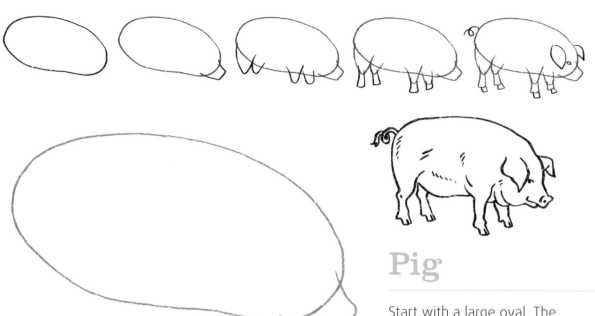

Pig

Start with a large oval. The legs are quite short and the snout is attached directly to the body. There's no visible neck. The snout is square and the floppy ears fall to either side of the head.

24th **day**

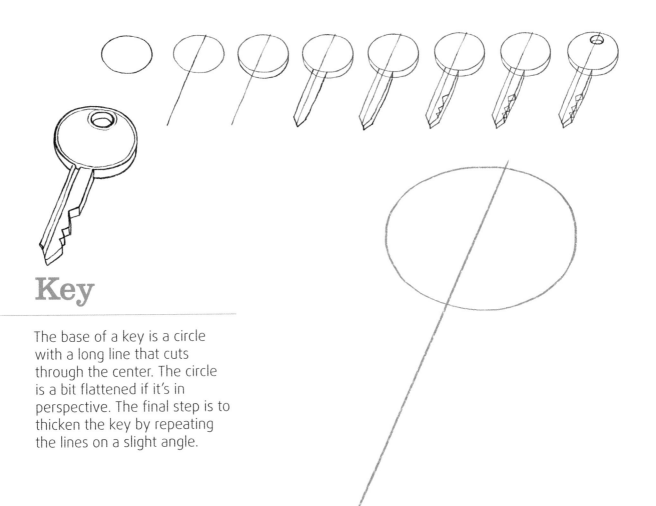

Key

The base of a key is a circle with a long line that cuts through the center. The circle is a bit flattened if it's in perspective. The final step is to thicken the key by repeating the lines on a slight angle.

25th day

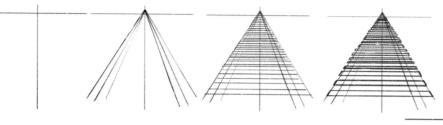

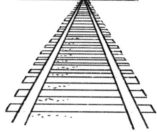

Rails

On the horizon line, draw a dot from which a first perpendicular line begins. On both sides of this line, keep adding lines, symmetrically, all meeting at the dot. Parallel to the horizon line, draw rails that get closer and closer together as they get farther away.

26th **day**

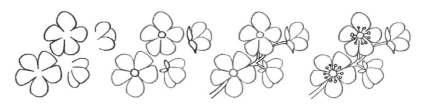

Cherry blossom

The flowers of a cherry tree have five petals. They are not all visible on closed flowers. For those that are open, the heart and the stamen are visible.

27th **day**

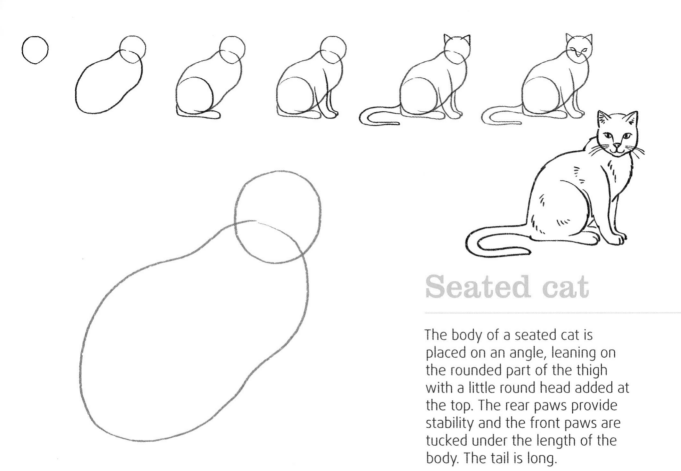

Seated cat

The body of a seated cat is placed on an angle, leaning on the rounded part of the thigh with a little round head added at the top. The rear paws provide stability and the front paws are tucked under the length of the body. The tail is long.

28th **day**

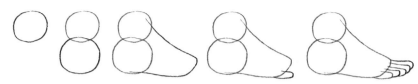

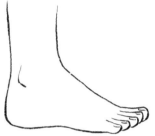

Foot in profile

Start by drawing the heel.
Lengthen it towards the top
of the ankle and the side by
adding a flat shape at the base
which inclines on the top of the
foot. Finish it off with toes, one
behind the other in a row.

29th **day**

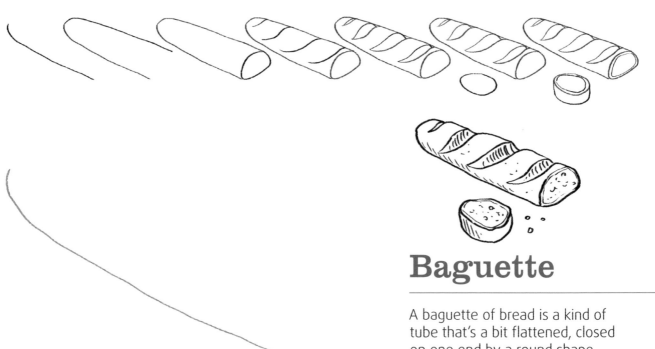

Baguette

A baguette of bread is a kind of tube that's a bit flattened, closed on one end by a round shape, and on the other by an oval representing the part that's cut. The slice must look pretty close to the same shape as the oval.

30th **day**

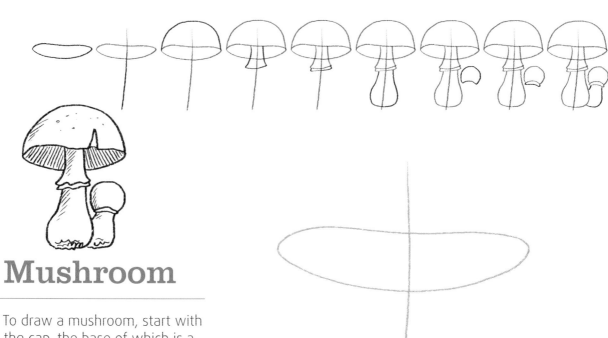

Mushroom

To draw a mushroom, start with the cap, the base of which is a deformed oval topped with a half-circle. The whole is drawn on a slant, surrounded by the foot.

31st **day**

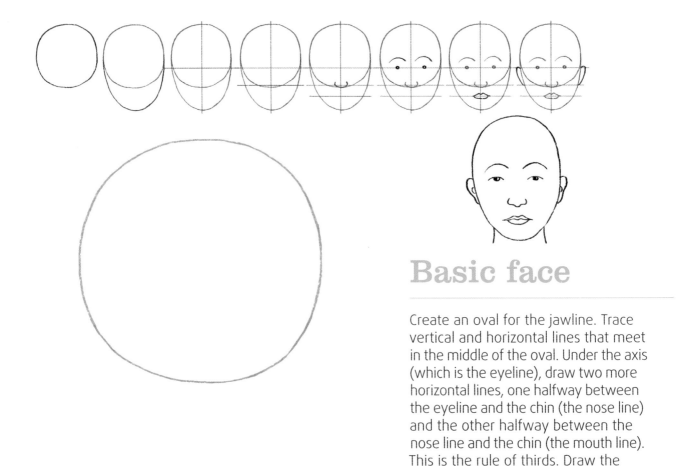

Basic face

Create an oval for the jawline. Trace vertical and horizontal lines that meet in the middle of the oval. Under the axis (which is the eyeline), draw two more horizontal lines, one halfway between the eyeline and the chin (the nose line) and the other halfway between the nose line and the chin (the mouth line). This is the rule of thirds. Draw the ears between the top two lines.

32nd day

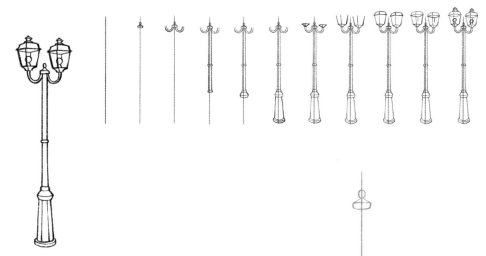

Lamp post

The most important part of a lamp post is the long vertical line on which everything hinges. This line can be dressed up in many different ways, and can be adorned with one or multiple lanterns. The lanterns are created by drawing small cubes that are stretched and transparent.

33rd **day**

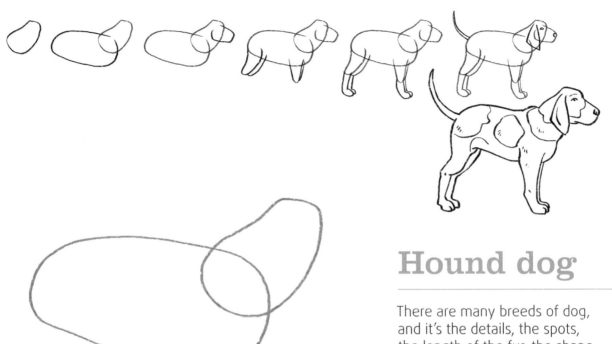

Hound dog

There are many breeds of dog, and it's the details, the spots, the length of the fur, the shape of the muzzle, ears and tail, that will help identify the dog breed.

34th **day**

Small leaf

To draw a small leaf, start with the stem. The next step is to draw the outline, adding the small ripples. The last step is to draw in the veins.

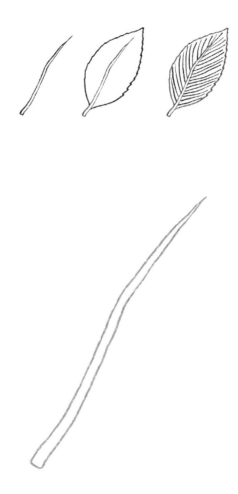

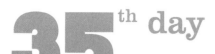

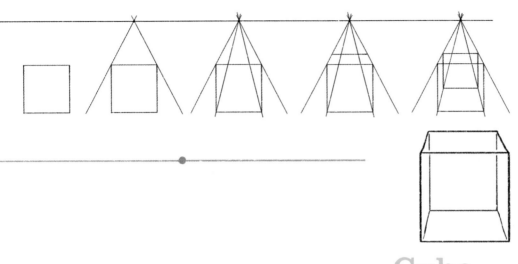

Cube

Start by drawing a perfect square. On the horizon line, in the middle and at the top of the square, draw the vanishing point. Join this point to the corners of the square. Draw new parallel lines behind.

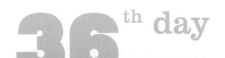

36th **day**

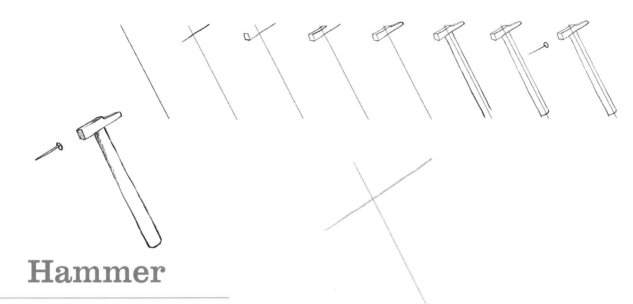

Hammer

The handle of the hammer is always perpendicular to the head that will hit the nail.

37th **day**

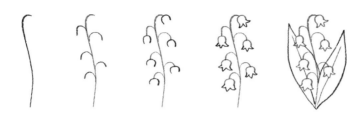

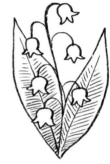

Lily-of-the-valley

Lily-of-the-valley is easily recognized by its small bells, alternately placed on either side of the curved stem. The last step is to add the long pointed leaves with some shading.

38th day

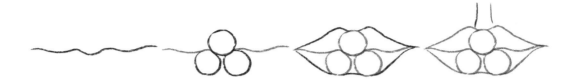

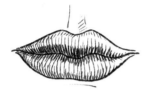

Mouth

Start with the undulating line between the two lips. Drawing small circles helps locate the widest points. Finish by drawing the top and the bottom of the mouth, and add shading to create fullness.

39th **day**

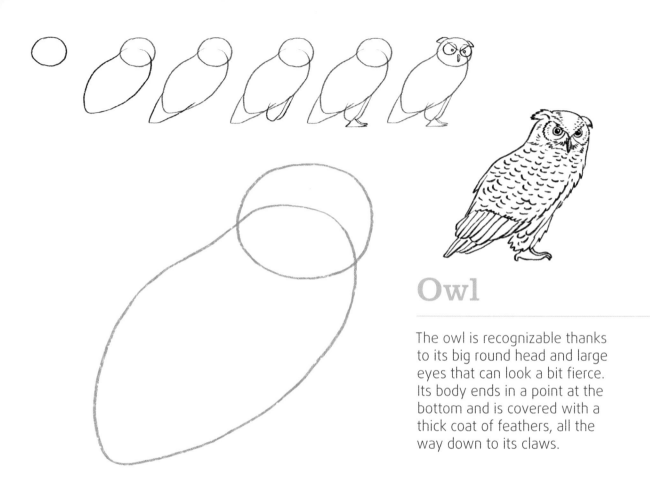

Owl

The owl is recognizable thanks to its big round head and large eyes that can look a bit fierce. Its body ends in a point at the bottom and is covered with a thick coat of feathers, all the way down to its claws.

40th **day**

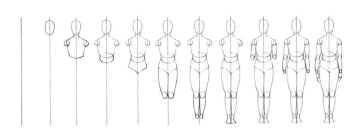

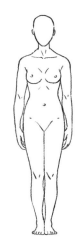

Woman

Start by drawing a head on a line. Then draw the chest, which drops from the slope of the shoulders. The ribs curve in as they reach the slightly rounded waist. The belly and waist are an oval, and the pelvis and lower belly resemble a pair of underwear. The arms are attached to the shoulders by small circles, as is each joint.

41st **day**

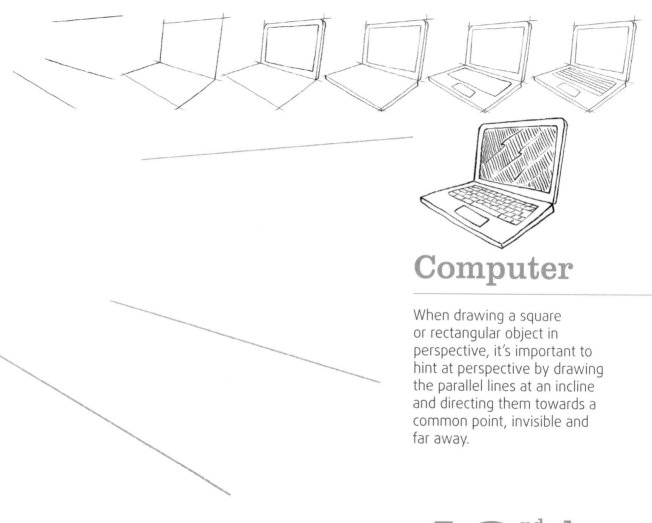

Computer

When drawing a square or rectangular object in perspective, it's important to hint at perspective by drawing the parallel lines at an incline and directing them towards a common point, invisible and far away.

42nd **day**

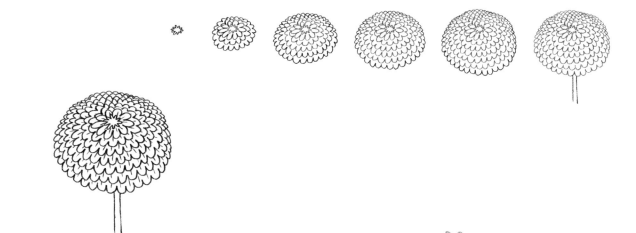

Chrysanthemum

The chrysanthemum is a big flower made up of a very large number of small petals. It looks like a big pompom. To give it perspective, draw the petals in the foreground bigger than those in the background.

rd day

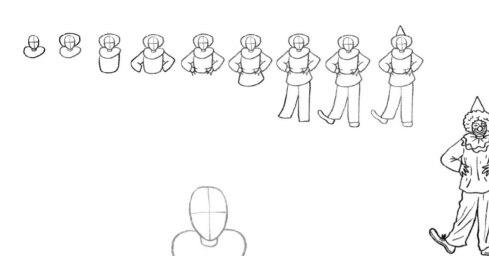

Clown

Clown costumes are so loose that they mask the shape of the body. For this reason, it's not necessary to first draw the proportions of the figure before dressing it. Start with the head and work downwards.

44th **day**

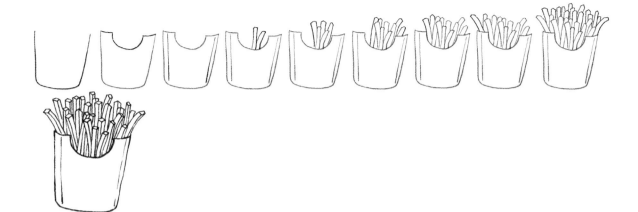

French fries

When a drawing includes many small elements, it's important to work from the front to the back. Start with the container, then add the fries at the front and fill in behind them.

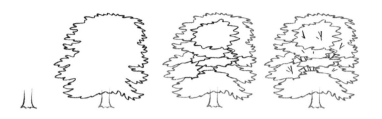

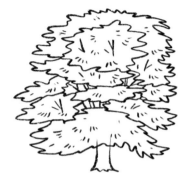

Tree

Start by defining the general shape of the tree. Next, trace the outline of the tree as a zigzag shape and fill it in with branches. Add details sparingly and let the tree "breathe" by leaving blank spaces.

46th **day**

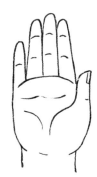

Palm
of the hand

Start with a rounded square
for the palm. Add the wrist
and the ball of the thumb,
then the fingers.

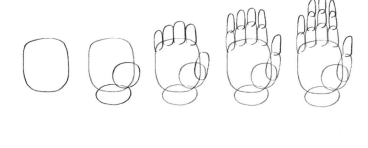

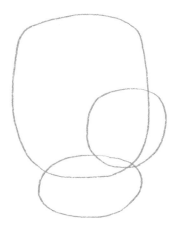

47th **day**

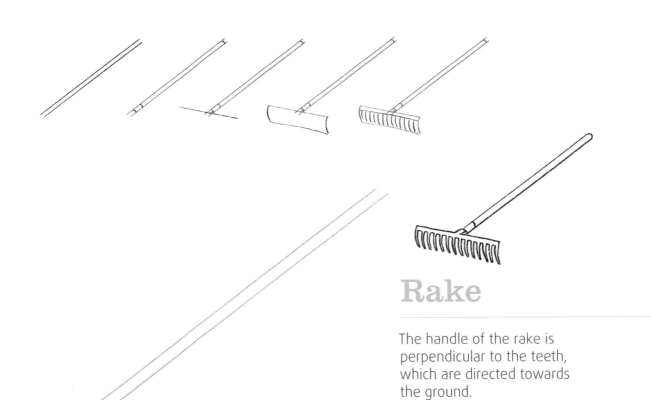

Rake

The handle of the rake is perpendicular to the teeth, which are directed towards the ground.

48th **day**

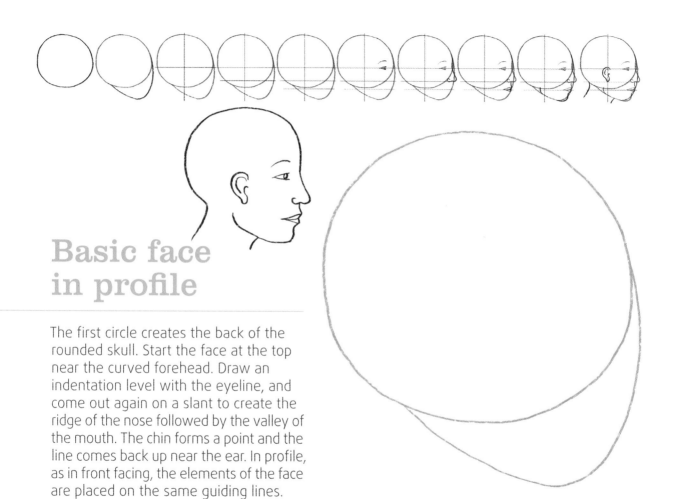

Basic face in profile

The first circle creates the back of the rounded skull. Start the face at the top near the curved forehead. Draw an indentation level with the eyeline, and come out again on a slant to create the ridge of the nose followed by the valley of the mouth. The chin forms a point and the line comes back up near the ear. In profile, as in front facing, the elements of the face are placed on the same guiding lines.

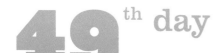

49th day

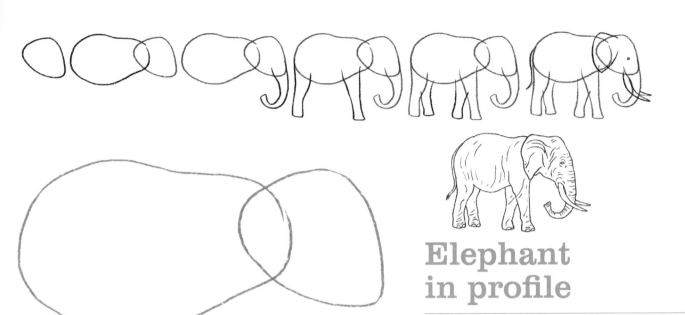

Elephant in profile

A sketched elephant is about the details: a large body, an almost triangular head, long thick legs, a trunk that touches the ground when uncurled, curved tusks, a thin tail, and small eyes. The mouth is not visible.

50th **day**

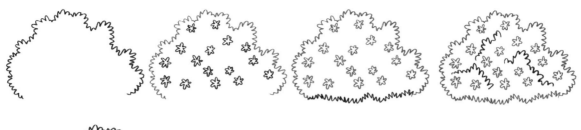

Flowering bush

To draw a flowering bush, start with the general shape of the bush, as you would for a tree, then fill it with flowers. The last step is to add details, giving the bush depth.

51st **day**

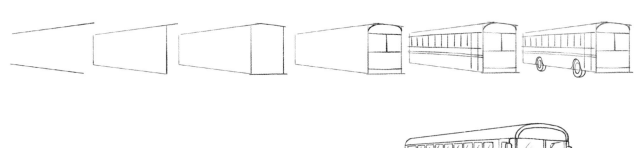

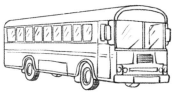

Bus

The general shape of a bus looks like an angled rectangle. As its shape is quite elongated, the perspective is very noticeable: if extended, the parallel lines would meet at an invisible point on the horizon.

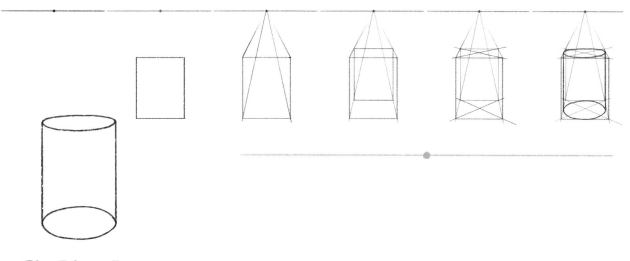

Cylinder

At this scale, the two circles are in perspective. Each is placed differently in relation to the horizon line: the bottom one is more visible than the one on top, which is flatter because it's closer to the eye line and as a result, the horizon line.

53rd **day**

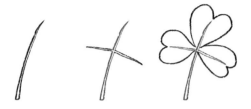

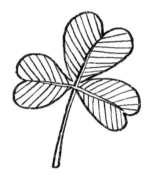

Clover

The stem of a clover is the shape of a cross on which grow three heart-shaped leaves.

54th **day**

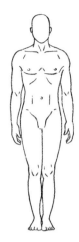

Man

The difference between drawing a man and a woman is mostly found in the width of the shoulders and torso (wider), and of the hips (slimmer). Rounding out the upper arms and thighs adds muscles.

th day

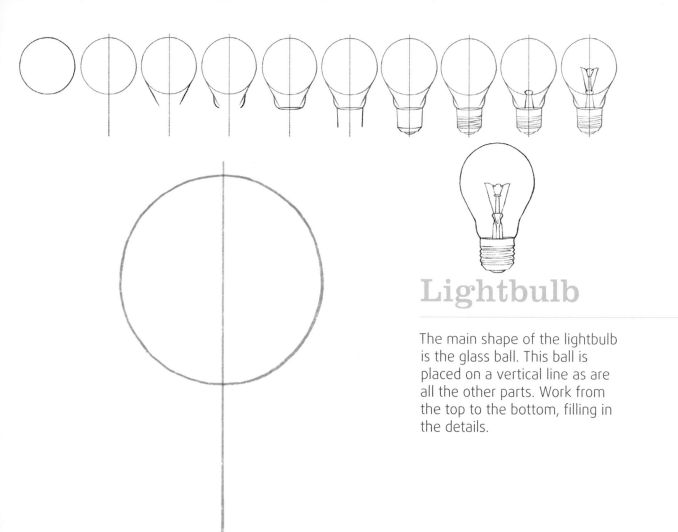

Lightbulb

The main shape of the lightbulb is the glass ball. This ball is placed on a vertical line as are all the other parts. Work from the top to the bottom, filling in the details.

56 th day

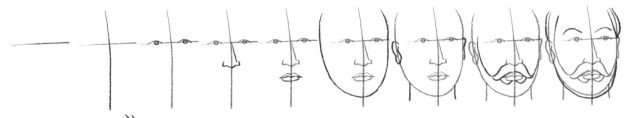

Bearded face

The beard covers the bottom of the face, extending from the hair. Leave a blank space around the mouth. Add short vertical lines to give the beard fullness.

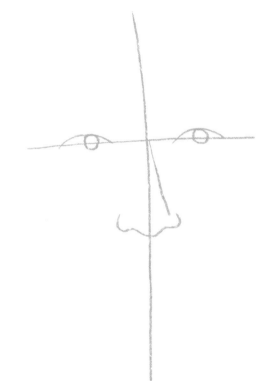

57th **day**

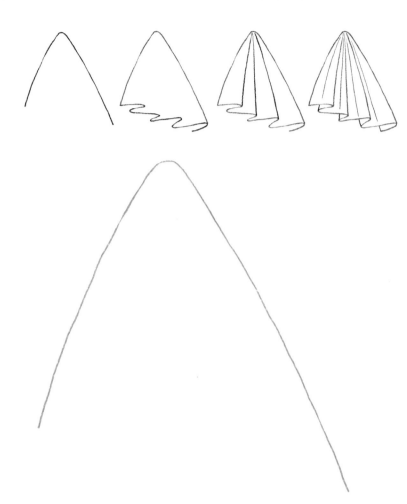

Transparent veil

To draw a transparent veil, draw the folds at the back lighter than those at the front. The thickness of the fabric, as well as the weight and stiffness, tend to flare the veil towards the bottom.

58 th day

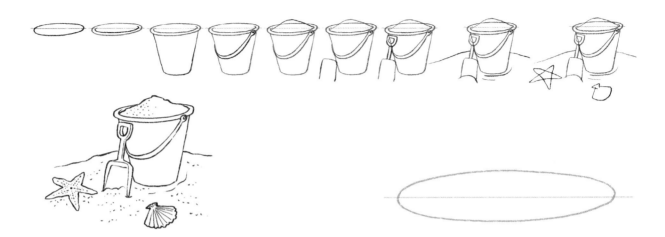

At the beach

The shape of a beach pail looks like a cylinder with a base that is narrower than the top. Add sand and themed objects.

59th **day**

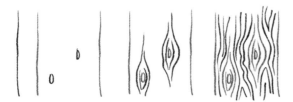

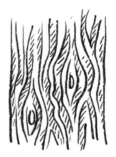

Bark

There are many different types of bark. Without going into detail, bark can be drawn starting with the knots and then accentuating the wavy lines.

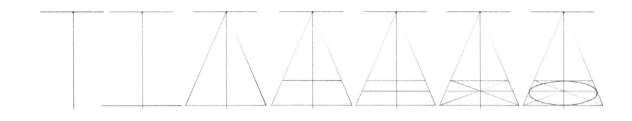

Circle in
perspective

It's quite difficult to draw a circle in perspective. There are no angles for the vanishing lines and it's not really an oval. The part of the circle that's the closest is bigger and wider than the part that is further away. The closer the circle is to the horizon line, and as a result the eyes, the thinner and flatter it appears.

 st day

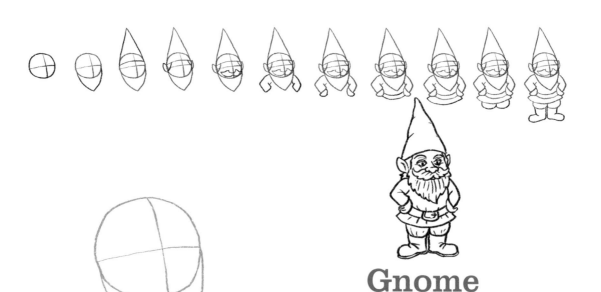

Gnome

There aren't really rules for the ideal proportions of a gnome. Everything is shrunken down and the head can be oversized. Because of this, it can be drawn directly as a dressed figure.

62nd **day**

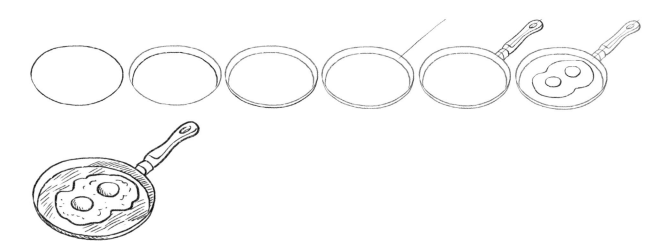

Frying pan

The frying pan is a circle in perspective with a raised edge and a straight line for the handle. The edge, or side, of the pan is a second circle, receding from the first, showing more of the interior edge than the exterior one.

63rd **day**

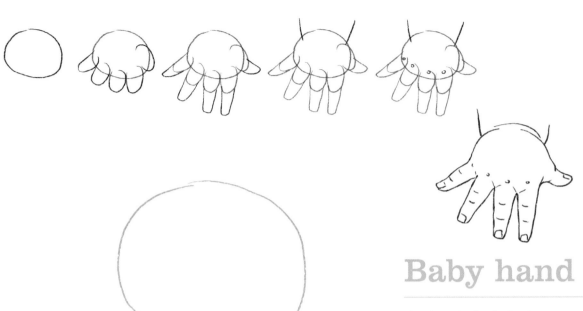

Baby hand

The hand of a baby has very short fingers that are slightly pointed on a big, chubby palm. Draw the palm first and then add the fingers and nails. Lines show where the knuckles are.

64th **day**

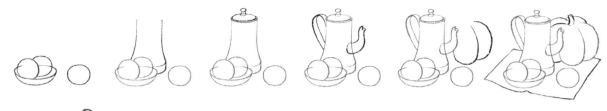

Still life

Starting with simple shapes, draw a composition of objects. Everything should be drawn in perspective: the objects in the foreground are bigger, proportionally, to those at the back. The object in the foreground partially masks the one behind, if it's close.

65th day

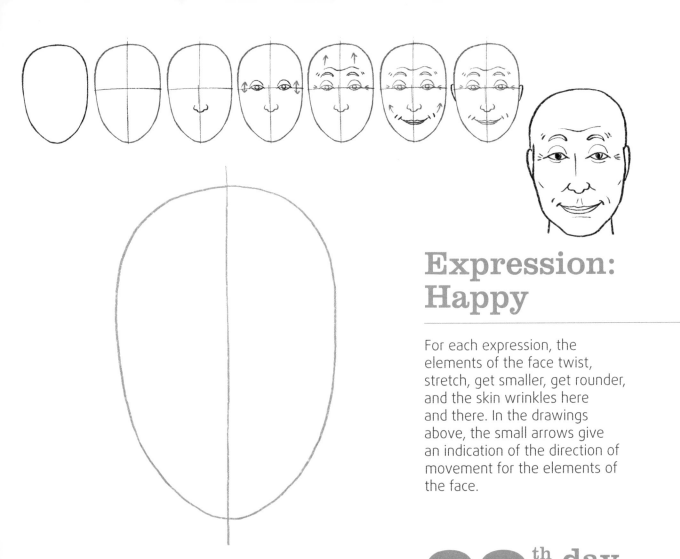

Expression: Happy

For each expression, the elements of the face twist, stretch, get smaller, get rounder, and the skin wrinkles here and there. In the drawings above, the small arrows give an indication of the direction of movement for the elements of the face.

66th **day**

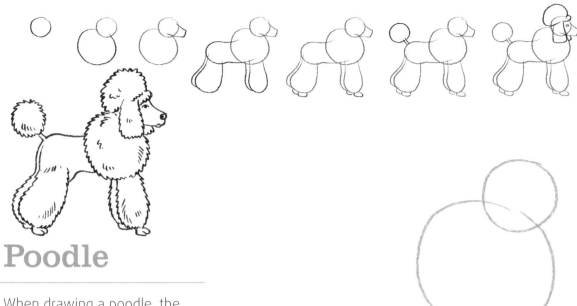

Poodle

When drawing a poodle, the shape of the hair is sometimes so unique that it's not necessary to begin by drawing the dog's body. Draw the general tufts of hair (neck, legs, tail), then add the paws and head.

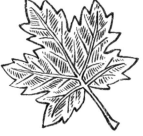

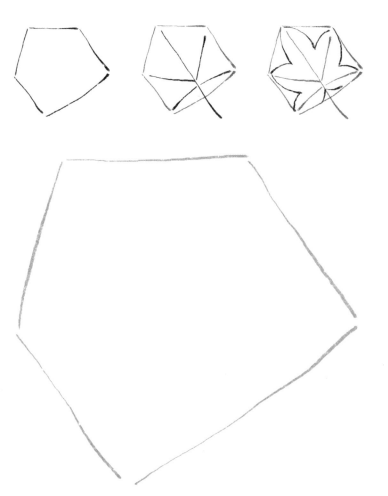

Maple leaf

To draw a maple leaf, start with the overall five-sided shape. Use two angled and one curved line to create five sections. Draw the outlines of five large points with smaller points around the edges. Finally, add the stem and veins.

68th **day**

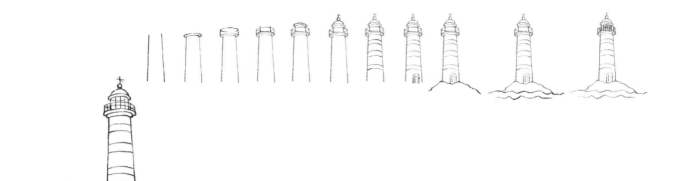

Lighthouse

The main shape of the lighthouse is a long cylinder that gradually gets smaller at the top. Next, decorate it with a small, round balcony as well as a small dome for the lamp (a type of lantern). Finally, at the base, draw the rocks and the sea.

69th **day**

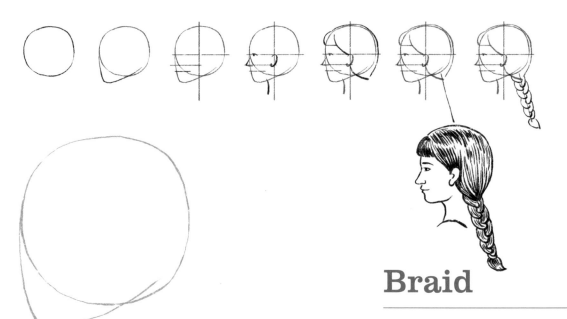

Braid

Once the head is drawn, it's the lines and their direction that give indications of the style of the hair, in this case braided. Add small lines of various weights to give volume to the hair.

70th **day**

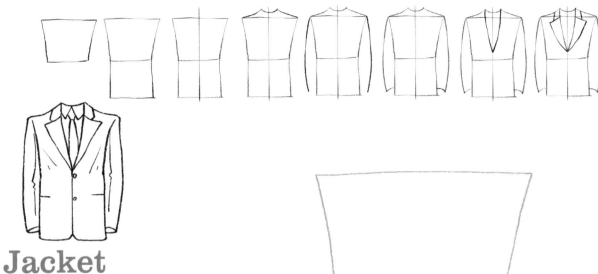

Jacket

A stiff piece of clothing isn't going to wrinkle naturally. The lines are straight and dynamic. Artificial creases can give shape to the cut of the suit.

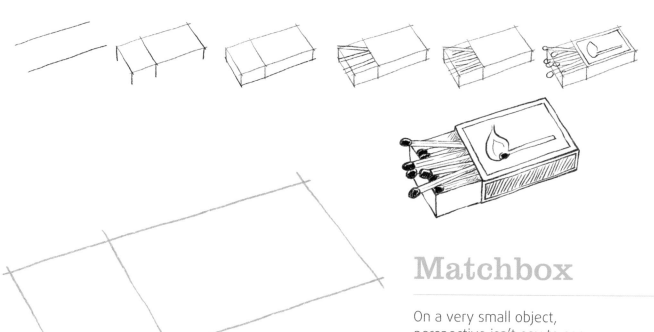

Matchbox

On a very small object, perspective isn't eay to see. Start by drawing the basic shape of a box, then add a slight incline to the lines heading towards a point on the far horizon. Then add the matches and fill in the small details.

72nd **day**

 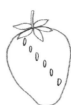 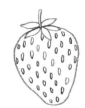

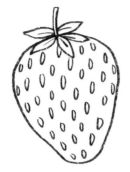

Strawberry

Start by drawing the general shape of a strawberry. Then, in any order, draw the stem with a few leaves, and the well and the many seeds.

73rd day

Rippling water

To draw the light undulations that small waves create on water, start with the most prominent lines. Then, by adding short lines, the impression of shadows in the dips of the waves will add movement.

74th **day**

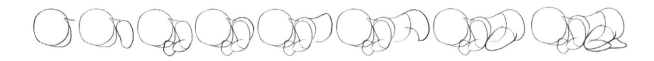

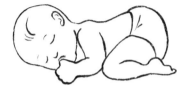

Sleeping baby

The head of a young baby is very big in proportion to its body. The baby is very flexible and folds itself into a ball. Start with the head and work sideways.

75th **day**

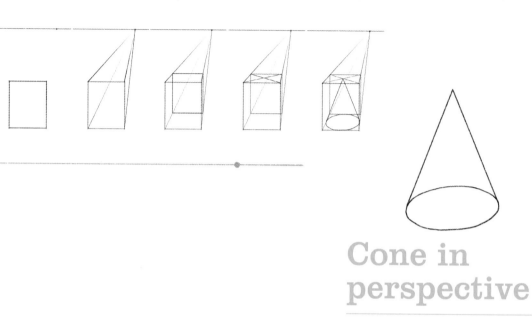

Cone in perspective

The base of a cone is a circle in perspective (a little flattened), and the body is a triangle moving into the distance.

76 **day**

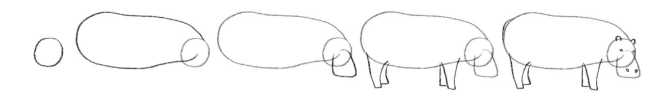

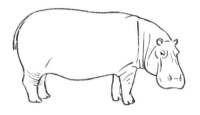

Hippopotamus

The body of the hippopotamus is a long, thick shape that ends with a very small ball to create the head. The nose and mouth are shaped like an elongated spatula. It has very small ears and very noticeable nostrils. Its legs are quite short.

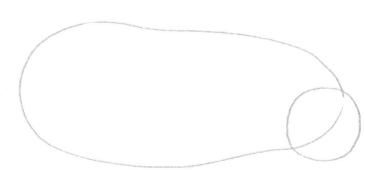

77th **day**

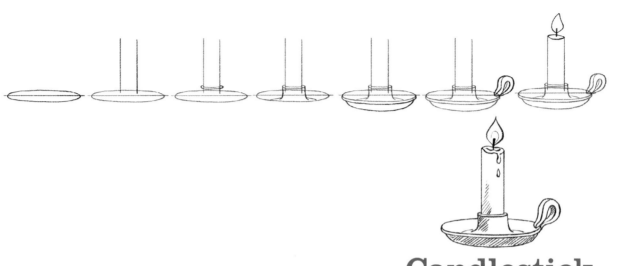

Candlestick

The candlestick is a circle in perspective. Draw a plate underneath, and a perpendicular candle at the center.

78th **day**

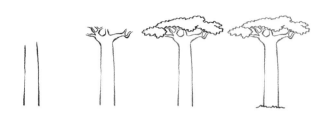

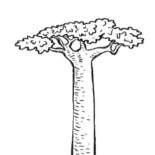

Baobab

To draw a very unique tree, like the baobab, start with the trunk. Add the branches and top with a layer of leaves.

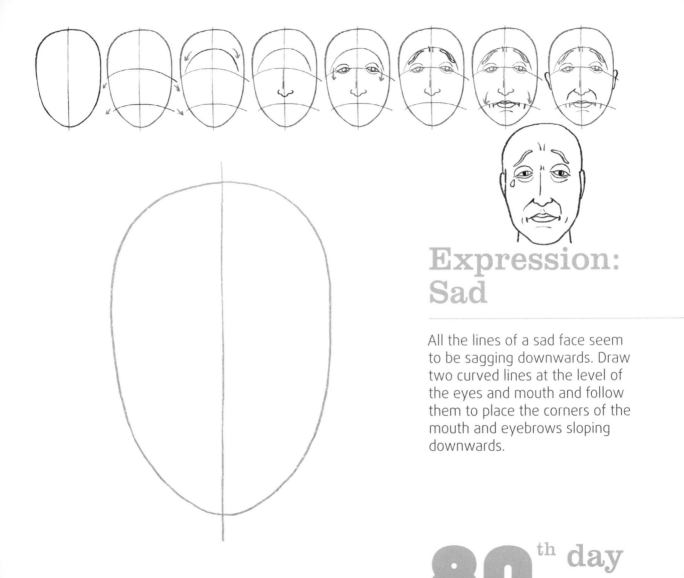

Expression: Sad

All the lines of a sad face seem to be sagging downwards. Draw two curved lines at the level of the eyes and mouth and follow them to place the corners of the mouth and eyebrows sloping downwards.

80th **day**

Sitting man

The top of the body remains straight with the arms and legs bending at the joints. Because the man is sitting the thighs are in perspective, and therefore shortened.

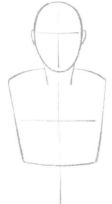

81st day

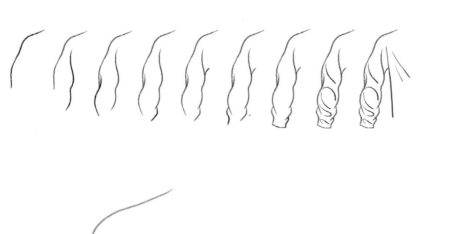

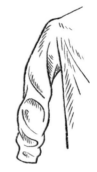

Sweater wrinkles

The sleeve of a soft sweater shows a lot of rounded wrinkles. Add light shadowing to the crevices of the folds to show the depth of the wrinkles, the bumps, and the crevices.

82nd day

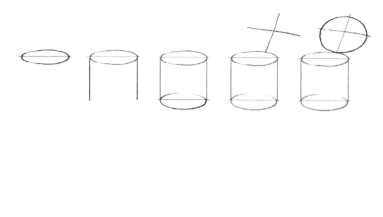

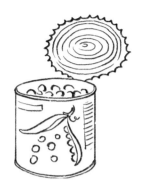

Tin can

To draw a can, start with a circle in perspective. This circle becomes oval, narrower at the top than at the bottom. By joining the two circles, a cylinder is formed. Add the can lid, drawing it more rounded if it's being shown face on, or more oval if it's pushed backwards.

83rd **day**

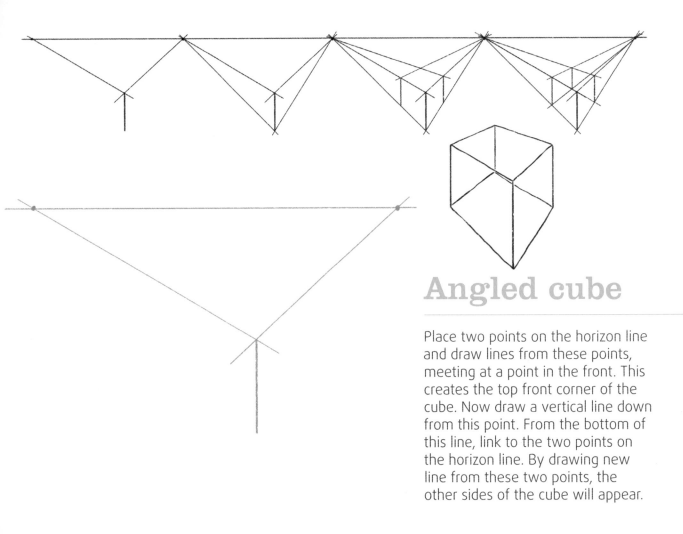

Angled cube

Place two points on the horizon line and draw lines from these points, meeting at a point in the front. This creates the top front corner of the cube. Now draw a vertical line down from this point. From the bottom of this line, link to the two points on the horizon line. By drawing new line from these two points, the other sides of the cube will appear.

84th **day**

Bearded
face in profile

A more or less long and thick beard lengthens the size of the chin in an accentuated manner. The small lines will help show the type of hair: straight, soft or curly...

85th **day**

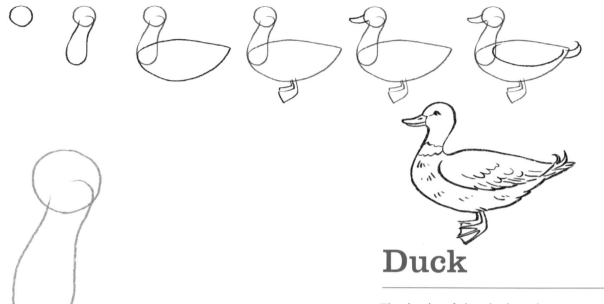

Duck

The body of the duck is the shape of an almond. On one end is the neck, which is flexible; add a small ball to create the head. On the other end, add a comma-shaped tail of feathers. The legs end in flippers and the beak is almost flat.

86th **day**

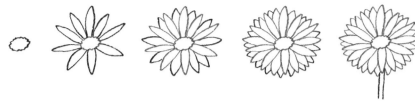

Daisy

The petals of the daisy are arranged in successive rows around the center. Depending on the angle, the petals seen in the foreground are bigger than those in the background.

87th **day**

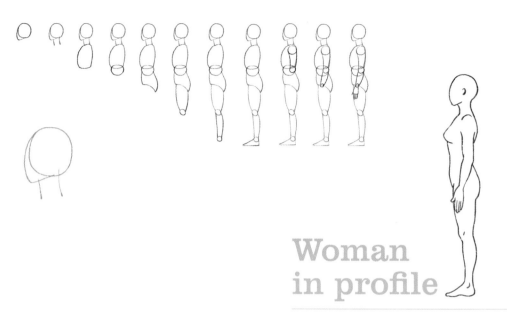

Woman in profile

Imagine a winding curve that runs from top to bottom: it creates a bump at the back of the head, swells the chest by digging out the back, rounds the buttocks by flattening the groin, rounds the thighs and calves, and ends at the feet.

88th **day**

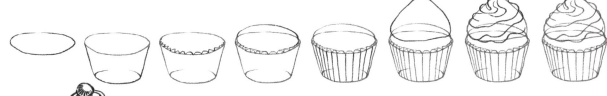

Cupcake

Start with the bottom, which is kind of like a flared cylinder. The big and small circles are in perspective, therefore, more oval. Fill with overflowing cake and cover with rippling frosting.

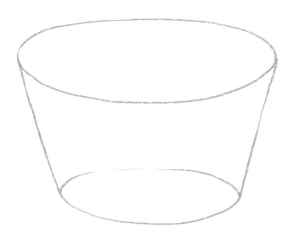

89th **day**

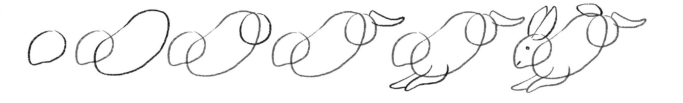

Running Rabbit

Even while running, the rabbit keeps its rounded shape. However, its body stretches and its legs and paws reach towards the front and back. Its nose pokes out towards the front, and its backswept ears "float" above the back. Lastly, add the pompom tail.

90th day

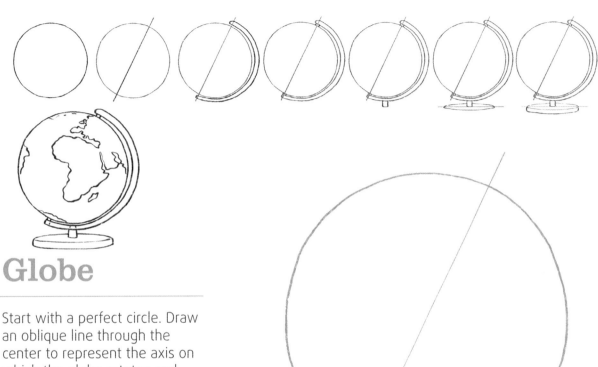

Globe

Start with a perfect circle. Draw an oblique line through the center to represent the axis on which the globe rotates and attaches to its stand. When drawing the continents, curve them to match the spherical shape of the globe.

 91st **day**

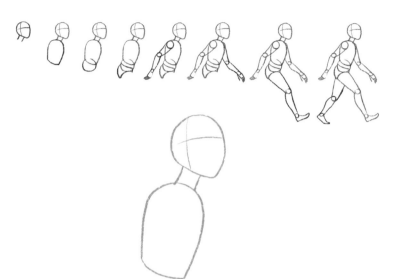

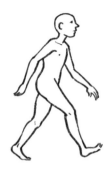

Man walking

When walking, the tendency is to swing the left arm and the right leg at the same time, and vice versa. The body is bent slightly forwards, and steps are initiated by the head, ending with the toes.

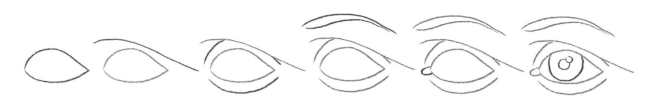

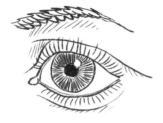

The eye

Start with the shape of the eye, which varies from person to person but is generally almond-shaped. The next step is to add detail to the eyelids. The iris of the eye is nearer to the nose. Add a highlight to the eye and shade the eyelids to create depth.

93rd day

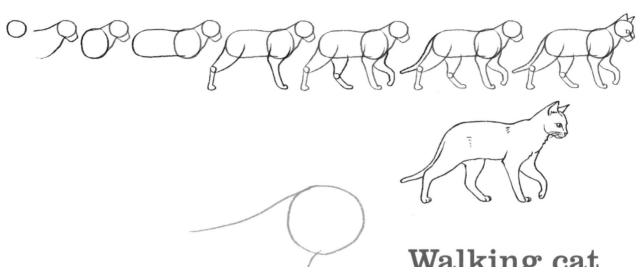

Walking cat

A cat elongates as it moves. The legs stretch out but the back is a solid trunk. The rear legs appear to bend towards the back, in the opposite direction to those of a human. The long tail gives a sense of balance.

94th **day**

Palm tree
No. 1

Start with the trunk, noting
that it is not especially straight,
and then dress it up with some
scales. Palm shoots pop out
from the top.

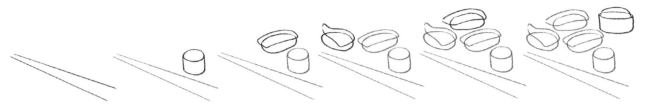

Sushi

Start with some simple shapes, mostly rounded, onto which curved elements are placed. It's important to add the appropriate details: black and smooth seaweed, as well as grains of rice.

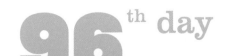

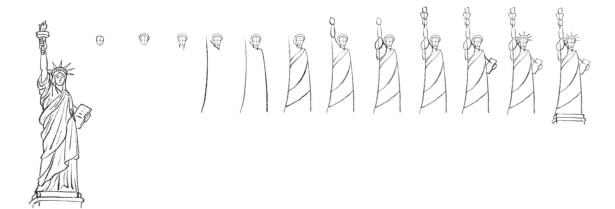

Statue
of Liberty

The general shape of the Statue of Liberty is a toga-like robe wrapped around a body. Start with a small head, add the robe with flowing wrinkles to show the body shape and then the arm holding a torch. Finally, adorn the head with a crown with seven spikes.

97th **day**

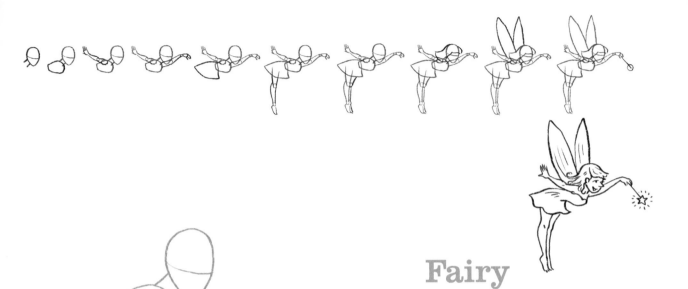

Fairy

Since a fairy is an imaginary creature, it's not necessary to respect the usual body proportions. Emphasis is on the small wings attached to a youthful, feminine body.

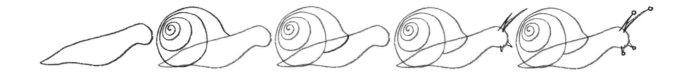

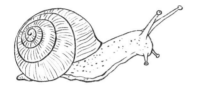

Snail

To start, draw a smooth and elongated shape to create the body. Add a spiral shell, and finish off with small antennae with eyes on the ends. The shell can be decorated with various patterns.

99th **day**

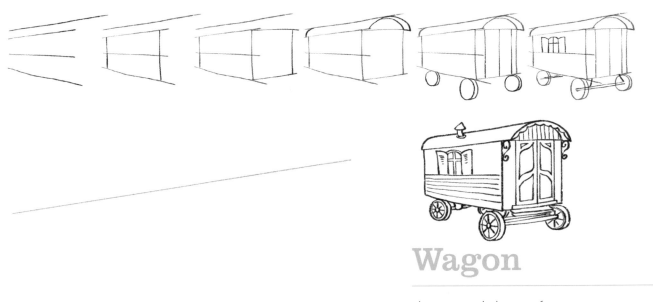

Wagon

The general shape of a wagon is an elongated rectangular box. Start by drawing four lines that grow further apart as they come to the fore; this gives perspective. Add a rounded roof, a door and a window, and then place the whole on four wheels.

100th **day**

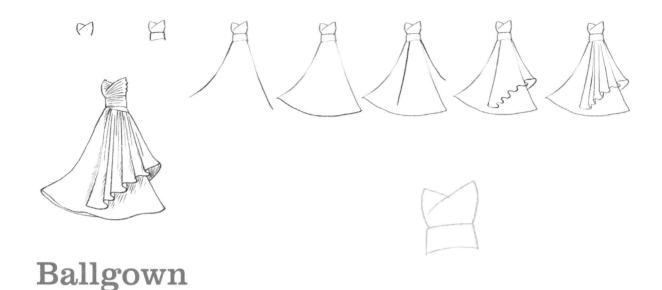

Ballgown

A ballgown can have lots of folds and gathers, creating waves at the base of the fabric. The bottom part of the dress is often flared and very full.

101st day

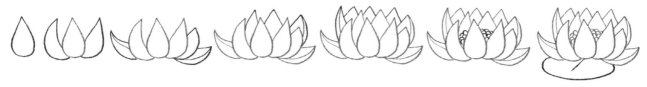

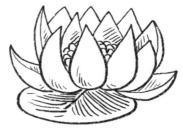

Lotus flower

The lotus is made up of a series of petals placed on a rounded base and pointing upwards, in a circle around the heart of the flower. The petals are more or less upright or opening outwards. The whole is placed on a pad of big rounded leaves.

102nd day

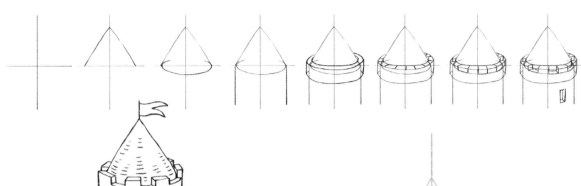

Castle tower

A tower is a cylinder topped with a triangle. Start by drawing crossed lines and add the triangle. At its base, draw a circle in perspective, transforming the top into a cone. The last step is to draw vertical lines on either side to create the walls.

103rd **day**

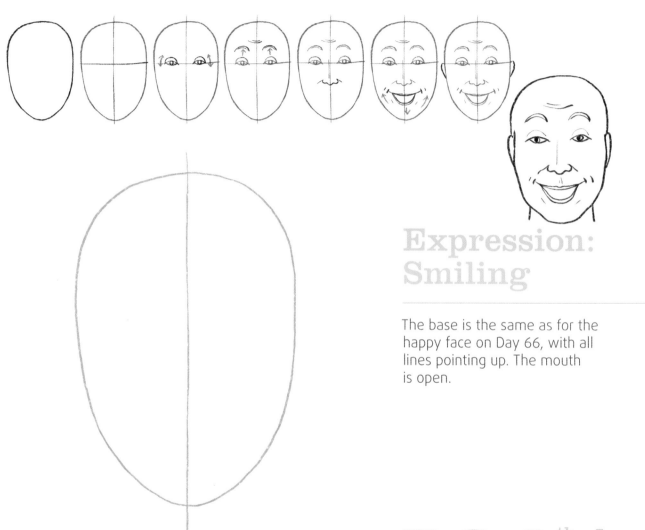

Expression: Smiling

The base is the same as for the happy face on Day 66, with all lines pointing up. The mouth is open.

104th **day**

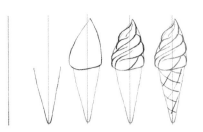

Ice cream cone

To create the effect of a soft serve ice cream cone, make sure the lines spiral to one side, creating the look of movement towards the top. The spiral should get narrower as it goes up. Some curves can go outside the general shape to give the impression of ice cream that is melting and running down the sides.

105th **day**

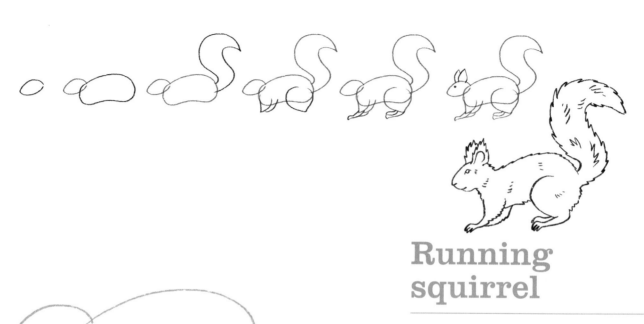

Running squirrel

While in movement, the squirrel stretches to climb and jump from branch to branch. Its flared tail undulates behind it. Its head is a bit removed from the shoulders and the paws are stretched.

Man in profile

The proportions of the different body parts stay the same as they are when seen face on. What changes is the silhouette; the bumps and crevices are different. Most obvious, the chest and the buttocks are less developed than those of a woman.

107th day

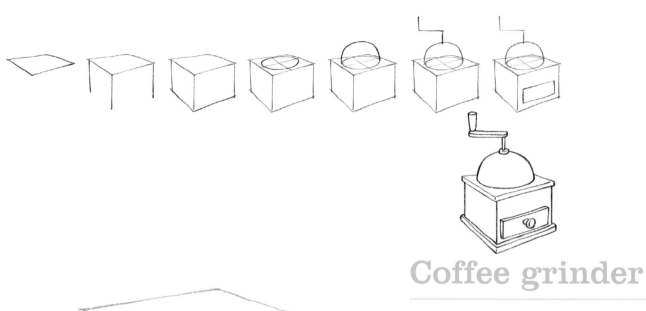

Coffee grinder

Start by drawing a cube in perspective. On top of this cube, add a circle and the base of a half-circle like a dome. The last steps are to draw the hand crank and the drawer.

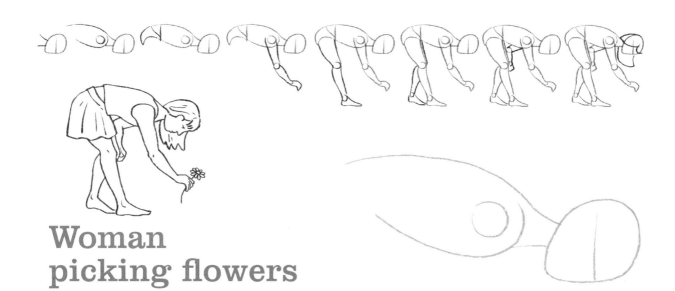

Woman picking flowers

To bend down, the body folds in two at the pelvis. One of the legs moves forwards to act as a counterweight. The hair hangs towards the ground due to gravity.

109 th day

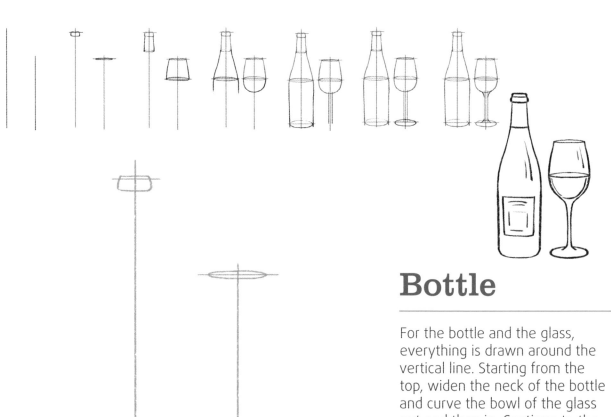

Bottle

For the bottle and the glass, everything is drawn around the vertical line. Starting from the top, widen the neck of the bottle and curve the bowl of the glass out and then in. Continue to the bottom of both, aligning them vertically.

110th **day**

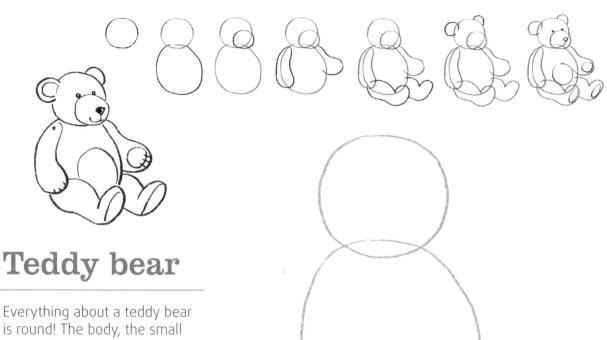

Teddy bear

Everything about a teddy bear is round! The body, the small paws, the head and the ears. Always remember to add a happy smile...

111th **day**

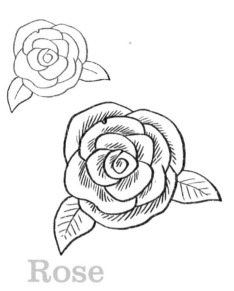

Rose

Start with a small circle and add petals in a spiral formation, getting increasingly bigger. The number of petals is up to you. Finish it off by shading the petals and adding a few pointed leaves with veins.

112th **day**

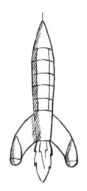

Rocket

The shape of a rocket is elongated and has no straight angles, allowing it to be as streamlined as possible. The body is a round tube pointing towards the sky and the fins arc downwards to increase speed.

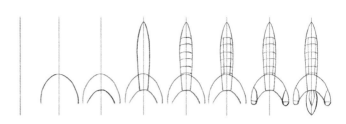

113th **day**

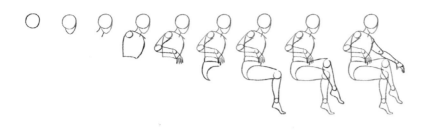

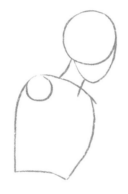

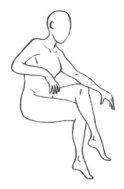

Seated woman

One of the ways to tell if a seated figure is male or female is its posture. The orientation of the feet, the inclination of the head... To draw crossed legs, start with the leg which has its foot on the ground and cross the other one on top.

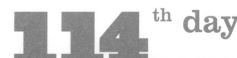

114th **day**

Bedside lamp

A bedside lamp is created around a central vertical line. The lampshade is a kind of cylinder, wider at the base. The lamp base is the combination of a slightly flattened ball and a cylinder with flared sides.

115th **day**

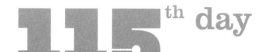

Fly

The body of a fly is a series of three balls increasing in size and stuck together in a row. Add the wings, followed by the eyes and the six legs, remembering to make the two sides symmetrical. Many flying insects have the same structure; it's the details, color and patterns that make them individual.

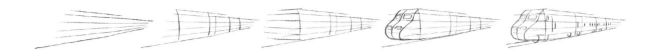

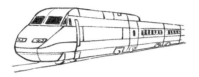

Train

Even though only a part of the train is drawn, its length contributes strongly to its perspective. All horizontal lines disappear towards an invisible point far away on the horizon. If there's room to draw it, the horizon line, as well as its vanishing point, are helpful.

117th **day**

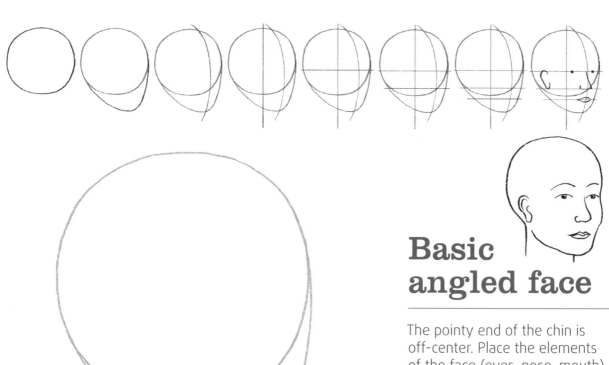

Basic angled face

The pointy end of the chin is off-center. Place the elements of the face (eyes, nose, mouth) on a curve connecting the top of the head to the chin and on the same horizontal lines as the face when seen face-on (see Day 32).

118th **day**

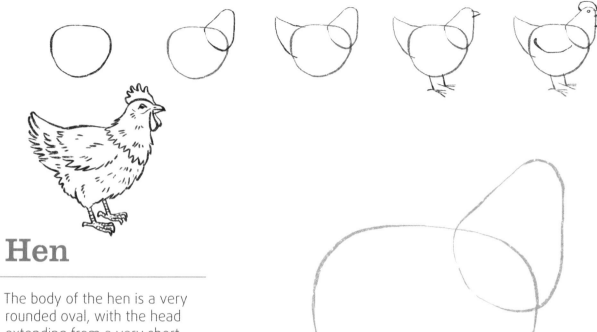

Hen

The body of the hen is a very rounded oval, with the head extending from a very short neck. On the opposite side, sketch the beginnings of a tail. If the hen puts down her head, the tail goes up, just like a seesaw.

119th **day**

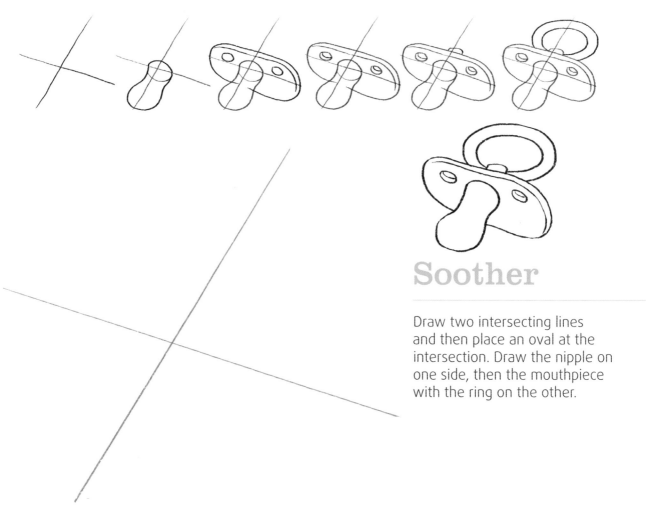

Soother

Draw two intersecting lines and then place an oval at the intersection. Draw the nipple on one side, then the mouthpiece with the ring on the other.

120th **day**

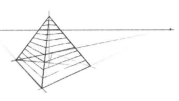

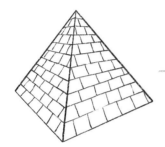

Pyramid

Start with a base made of a square in perspective. Join the corners of the square at the center. From this point, draw a vertical line. End by joining the top of this vertical line to the corners of the square. Draw lines parallel to the pyramid base to make the bricks.

121st day

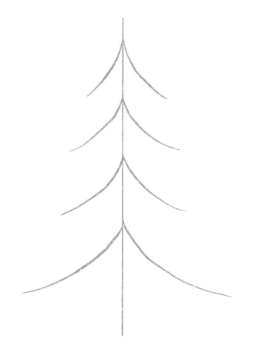

Christmas tree

Start with a central axis, adding the symmetrical sloping branches decorated with foliage on either side. Finally, add depth by filling in the greenery at the front of the tree.

122nd day

A child

As a child, the body of a boy or girl is very similar. The hips are slim and the muscles have not yet developed. Start with the head and work downwards, keeping the sides symmetrical.

123rd **day**

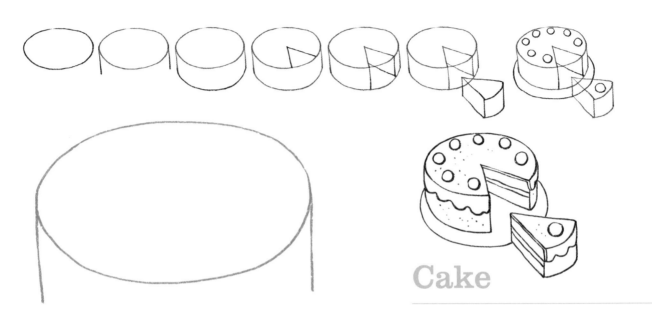

Cake

The base shape is a big cylinder. The circles are flattened by perspective. If a slice is cut, it must be of the same width as the empty space.

124th **day**

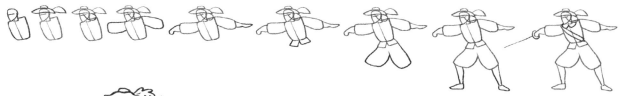

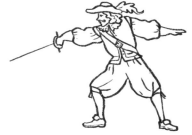

Musketeer

No need to draw the body first; start with the musketeer's clothing, making sure it is billowy. The pose is energetic, the legs well positioned, the entire body leaning towards the end of the sword.

125th **day**

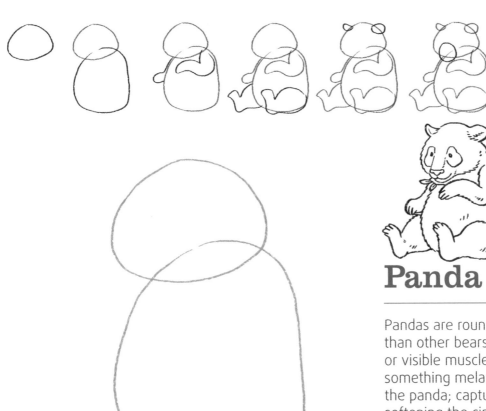

Panda

Pandas are rounder and stockier than other bears. No angles or visible muscles. There is something melancholic about the panda; capture this by softening the circles around the eyes and adding a smile. Don't forget to add the spots to the bear's coat.

126th day

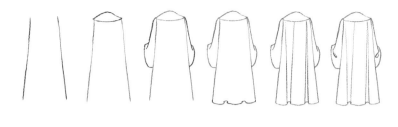

Coat

When drawing clothing, it's important to show the texture and weight of the fabric. This coat falls heavily, and the weight and thickness of the cloth make it flare at the bottom.

127th **day**

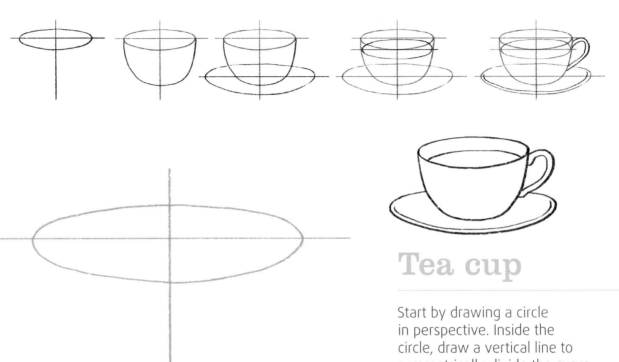

Tea cup

Start by drawing a circle in perspective. Inside the circle, draw a vertical line to symmetrically divide the curve of the cup. Within the axis, draw a big circle in the saucer and a small circle in the cup that will become the liquid in the cup.

128th **day**

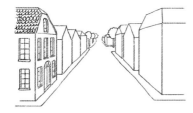

Front view
of a street

Start at the center of the street: the
horizon in the middle of the scene,
the vanishing point at the center.
The vanishing lines spread out on
both sides, symmetrically. Draw the
boxes that will form the houses on
this grid. The horizontal lines facing
you need to be parallel to the
horizon line. The vertical lines are
always drawn perpendicularly.

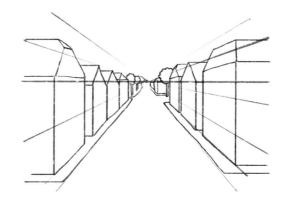

129th **day**

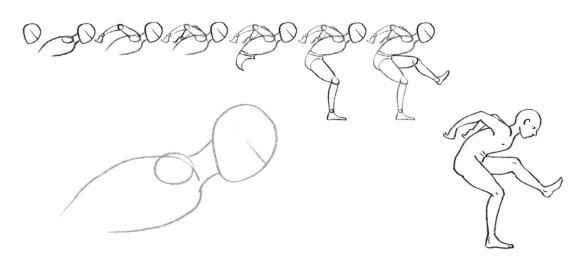

Kick

In order not to fall, the top of the body leans forwards when the character raises its foot. The leg that remains on the ground is gently flexed. Once the body of the figure is drawn, dress it as you wish.

130th **day**

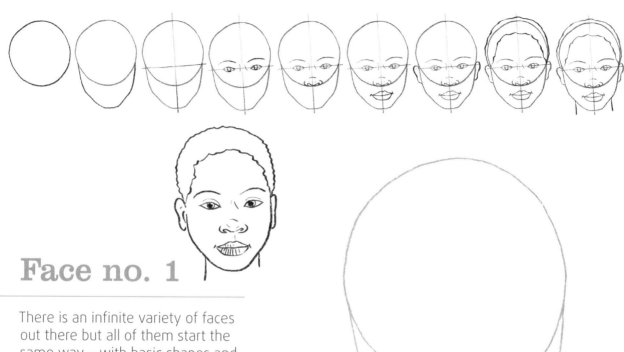

Face no. 1

There is an infinite variety of faces out there but all of them start the same way – with basic shapes and guidelines. Start with a circle for the top of the head, add a semi-circle for the chin, then draw a horizontal line to position the eyes and a vertical line for the nose and lips. Now you can start looking at the details that make this face unique.

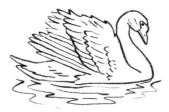

Swan

A swan is a duck with a very elongated neck that bends easily. Its big wings, when unfurled, reveal numerous feathers.

132nd **day**

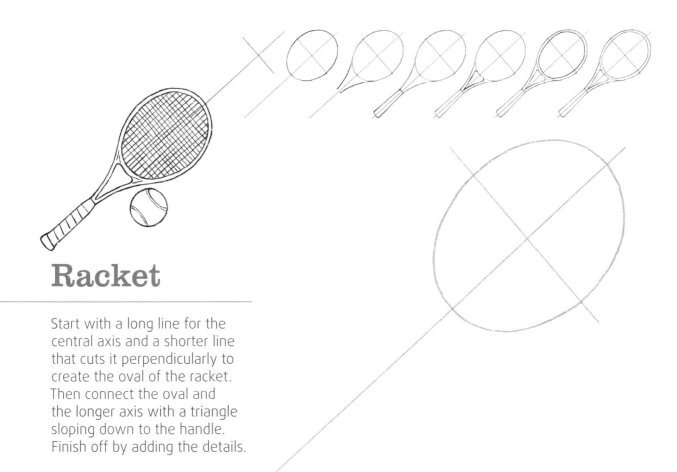

Racket

Start with a long line for the
central axis and a shorter line
that cuts it perpendicularly to
create the oval of the racket.
Then connect the oval and
the longer axis with a triangle
sloping down to the handle.
Finish off by adding the details.

133rd day

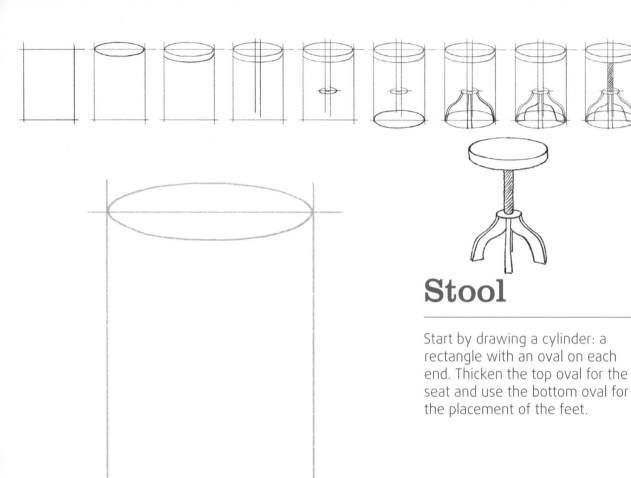

Stool

Start by drawing a cylinder: a rectangle with an oval on each end. Thicken the top oval for the seat and use the bottom oval for the placement of the feet.

134th **day**

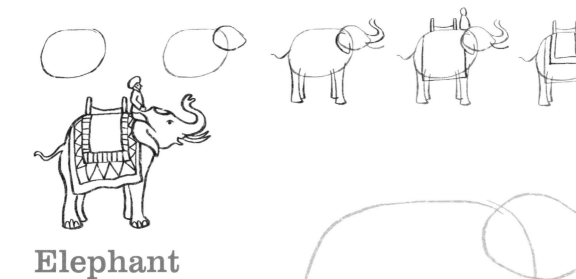

Elephant

Draw ovals for the body and head, then add a curved trunk and legs. Next, cover the elephant with a big rug and pose a person on its back, between the two ears.

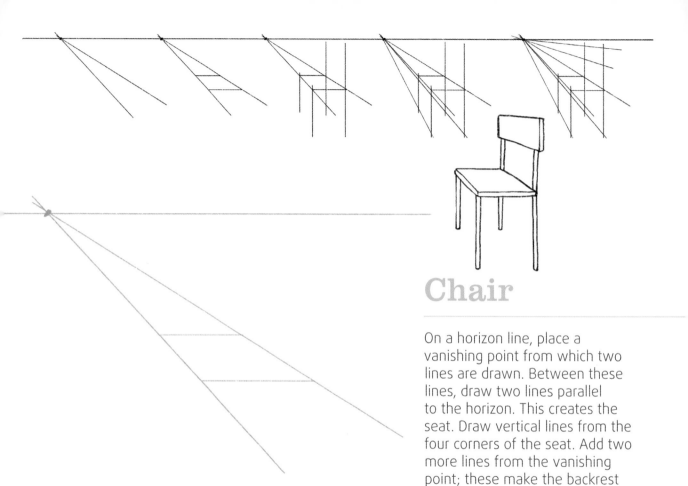

Chair

On a horizon line, place a vanishing point from which two lines are drawn. Between these lines, draw two lines parallel to the horizon. This creates the seat. Draw vertical lines from the four corners of the seat. Add two more lines from the vanishing point; these make the backrest and the lengths of the chair legs.

136th **day**

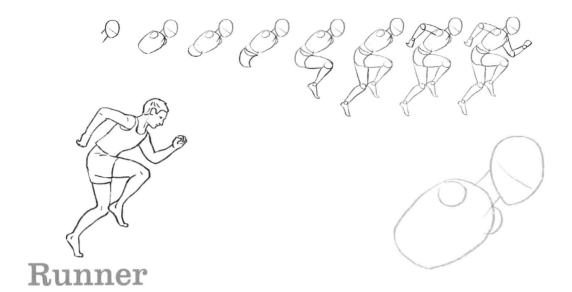

Runner

When running, legs and arms are bent, alternating left leg/ right arm and vice versa. The body is propelled forwards. The faster the running, the less the heels touch the ground.

137th **day**

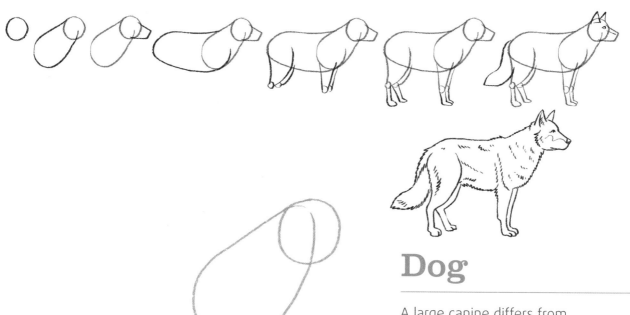

Dog

A large canine differs from smaller dogs by having a straighter body with more angular shapes, especially in the snout, which can be pointy depending on the breed. A dog has a wider ribcage and a tucked abdomen and back, and large muscular thighs.

138th **day**

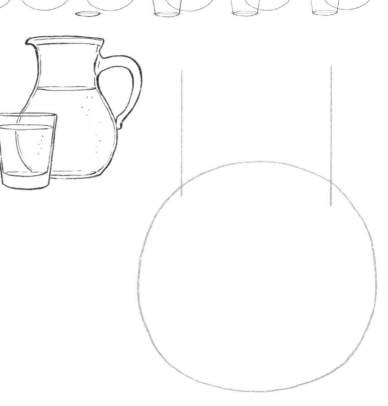

Glass
and pitcher

When viewing an item behind water, the item will appear distorted. This is demonstrated when looking through a glass of clear water to something behind, even if it too is clear water or clear glass. The image of the part of the container behind the water will be distorted or even appear to vanish.

139 th day

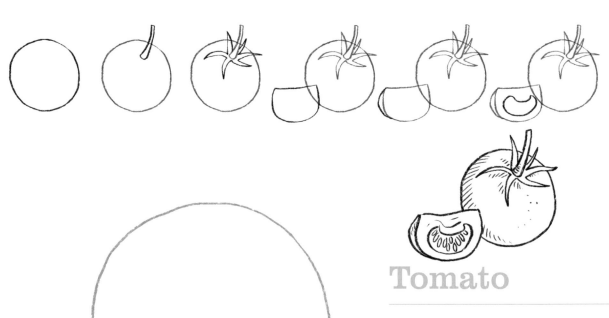

Tomato

What differentiates a tomato from other round fruits or vegetables is mostly its color. When drawing without color, it's important to accentuate the pointed leaves around the stem. And, on a slice of tomato, the crevice with the pulp and the seeds.

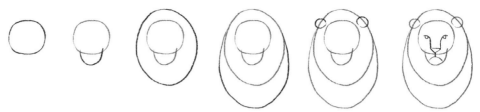

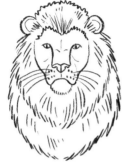

Lion's head

To draw a lion's head from the front, start with a small circle. Add part of a circle below for the mouth and nose. Surround the face with a thick mane and tuck the ears on either side. The lines of the face are symmetrical. Add detail, including lines to create the fur of the thick mane and chest.

141 st **day**

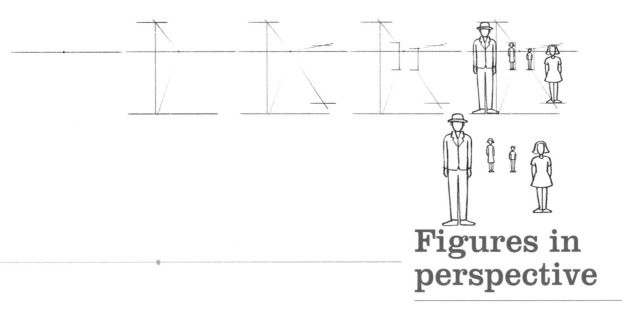

Figures in perspective

The lines leading to a vanishing point provide perspective and scale for what is found between us and the horizon. Everything leads to that point, shrinking as distance increases. Using the vanishing point for reference, have some fun placing figures, animals or objects at different spots between the bottom of the page and the horizon line.

142nd **day**

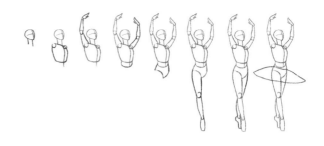

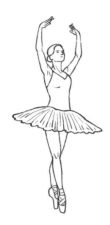

Ballerina

The proportions of the body of a ballerina are stretched while in motion: upright, arched and slender. She is elongated but still in proportion.

143rd **day**

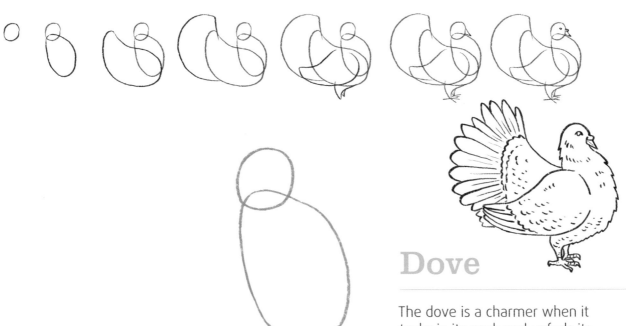

Dove

The dove is a charmer when it tucks in its neck and unfurls its fan of feathers. The shape of its body makes it tilt forwards. From its round head to feathers with rounded tips, it is all about curves.

144th **day**

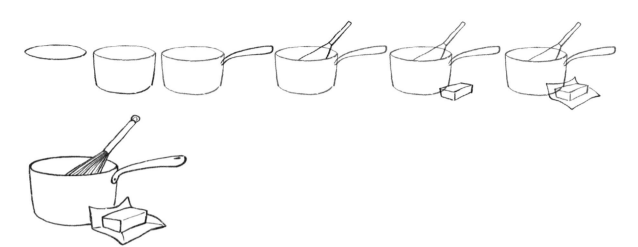

Saucepan

Start with the opening of the saucepan which is a circle in perspective and, therefore, an oval. Next draw the sides to determine the height of the pan and close the base, and add the handle. Finally, add the accessories.

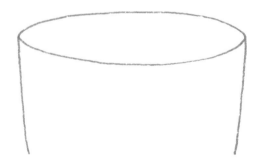

145th day

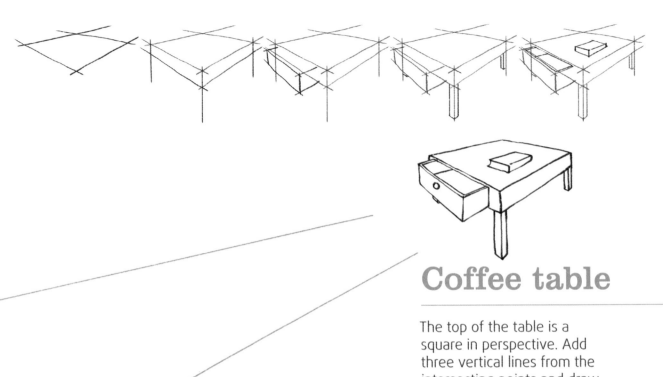

Coffee table

The top of the table is a square in perspective. Add three vertical lines from the intersecting points and draw two lines to show the thickness of the table. The depth of the drawer must be less than the depth of the tabletop. Add legs and accessories, remembering to respect the vanishing lines.

146th **day**

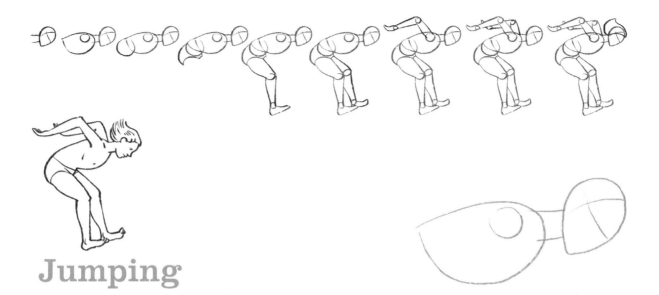

Jumping

When jumping, the body bends forwards while the arms bend towards the back. The feet are flexed, hair floating towards the back.

147th **day**

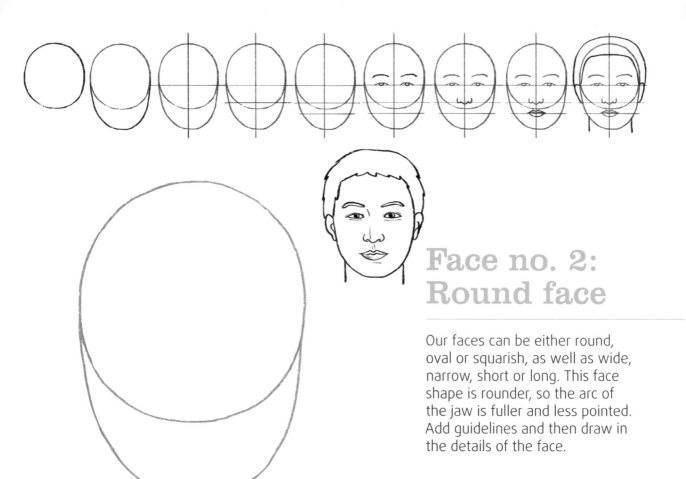

Face no. 2: Round face

Our faces can be either round, oval or squarish, as well as wide, narrow, short or long. This face shape is rounder, so the arc of the jaw is fuller and less pointed. Add guidelines and then draw in the details of the face.

148th day

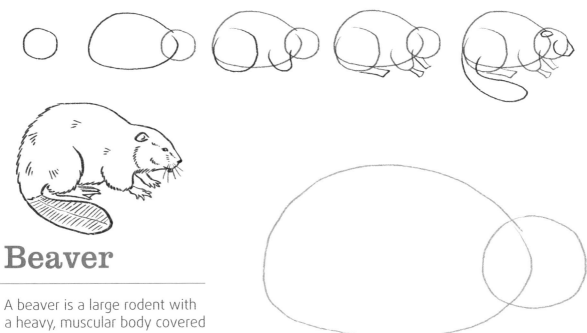

Beaver

A beaver is a large rodent with a heavy, muscular body covered in dense fur, a squared muzzle and tiny ears. But, it's mostly the big rodent teeth and paddle tail that renders the beaver immediately identifiable.

149th **day**

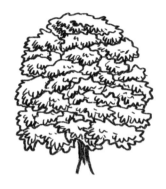

Tree

Build layers of branches and gradually create the shape of a tree. Add small lines to give the impression of leaves.

150th **day**

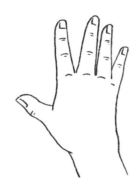

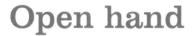

Open hand

Hands, like faces, can be a challenge to draw but success is easily achieved by breaking it down into individual parts. To draw an open hand, the fingers must be spread out, but not in an even way. And, of course, you have a model whenever you want!

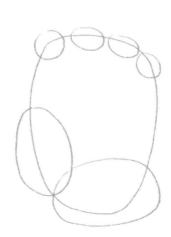

151 st **day**

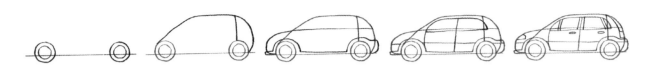

Small car

Start by drawing the wheels on the horizon line. Then connect these wheels to the chosen shape, depending on the purpose of the car, or a particular model. Details complete the picture.

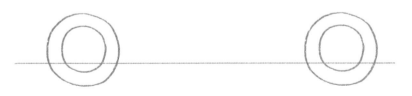

152nd **day**

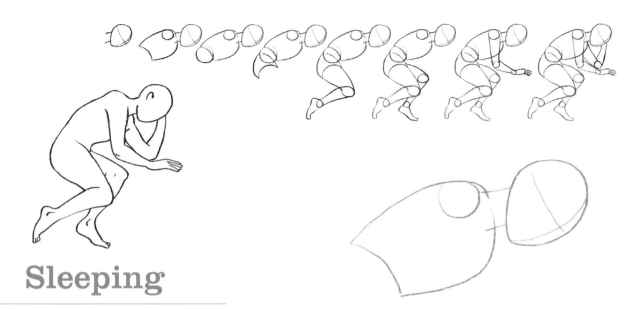

Sleeping

In this position (lying sideways),
a leg, an arm and the head
mask parts of the body. The
back and hips are rounded and
the head follows the spine.

153rd **day**

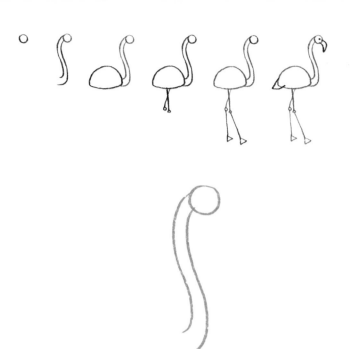

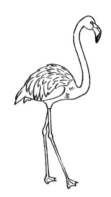

Flamingo

The body and feathers of a flamingo resemble a flat-bottomed circle. From one side stretches its long S-shaped neck curving to its body. Its heavy feathers and tail end in a point. The head is tiny but it has a big parrot-like beak angled towards the ground. The legs are very long, thin and end in webbed feet.

154th **day**

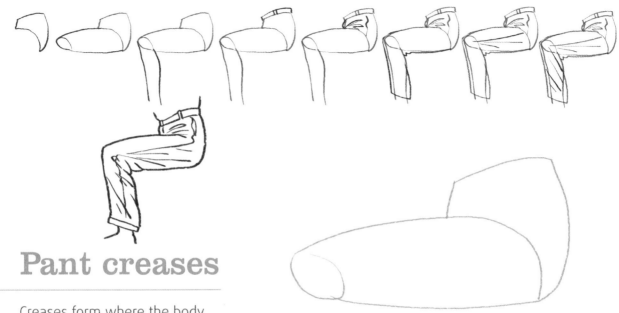

Pant creases

Creases form where the body bends. Here, for example, at the pelvis and the knee. The knee and the bum pull on the fabric, and as a result, the creases start at those two points and flare out.

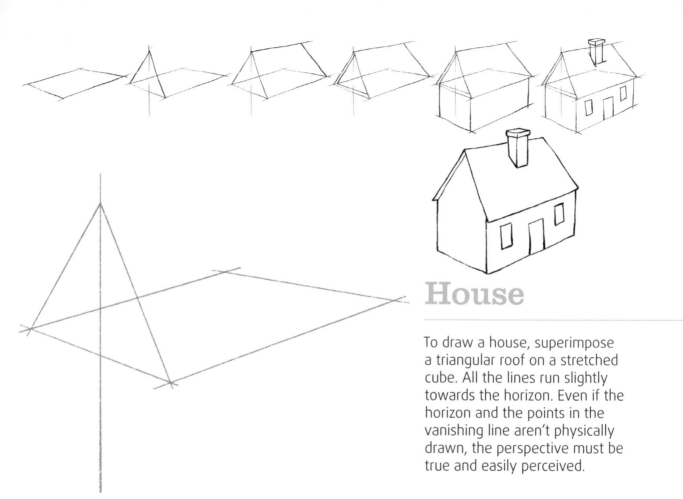

House

To draw a house, superimpose a triangular roof on a stretched cube. All the lines run slightly towards the horizon. Even if the horizon and the points in the vanishing line aren't physically drawn, the perspective must be true and easily perceived.

156th **day**

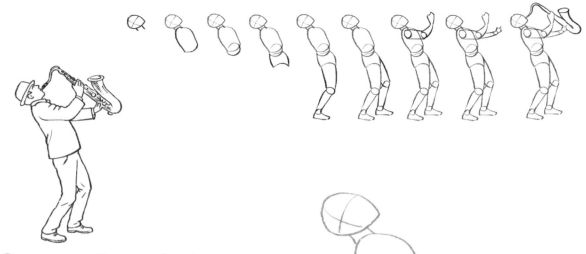

Saxophonist

The body is curved towards the back; the legs are firmly planted on the ground. The important part is to suggest motion and energy.

157th **day**

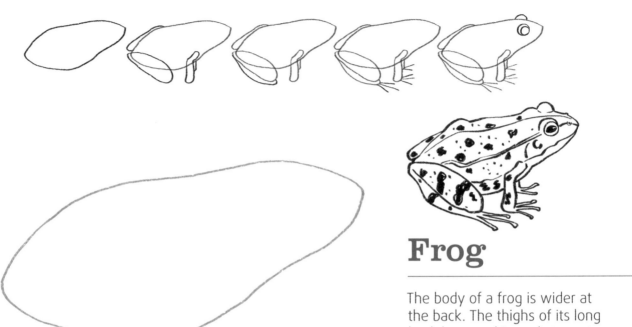

Frog

The body of a frog is wider at the back. The thighs of its long back legs are big and strong to help it bounce. Its front legs are very small in comparison. Its head is pointed and its eyes look like two marbles, placed on top. Once you have a line drawing of the frog, you can add details according to its species.

158th day

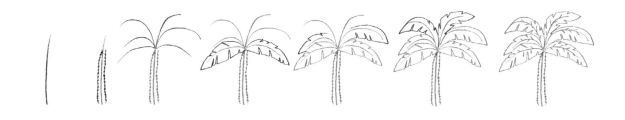

Palm tree
No. 2

To draw this palm tree, start with the trunk, filling it in with a grid pattern. Then draw long curved lines for the palms and surround them with the easily-recognized leaves.

159th **day**

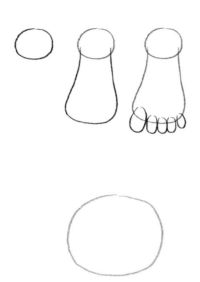

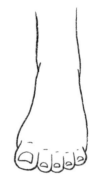

Front view of a foot

Start directly with the ankle, as the heel is not visible. The body of the foot is wider at toe level, and the toes are aligned biggest to smallest.

160th **day**

Shadows
and shapes

If there's only one source of light, shadows will be found on the same side of each shape. Depending on the shape, the shadow will be rounded, straight, angled or cut by the sides of the shape.

161st **day**

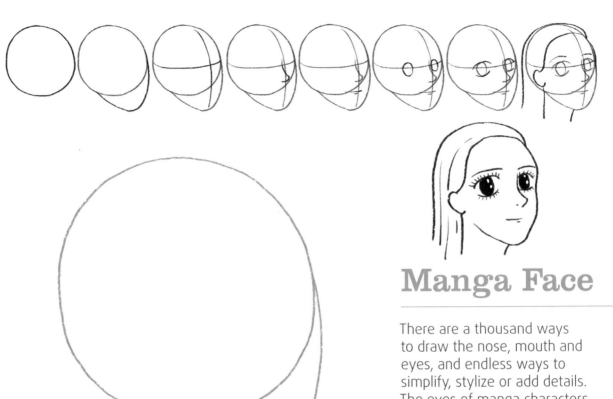

Manga Face

There are a thousand ways to draw the nose, mouth and eyes, and endless ways to simplify, stylize or add details. The eyes of manga characters, for example, are particularly big and bright. The mouth can have plump lips or only be a line.

162nd **day**

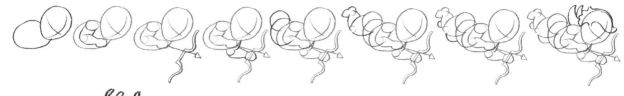

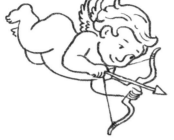

Cherub

A cherub is a small baby with wings. Generally, it is drawn with a particularly chubby face and body.

163rd day

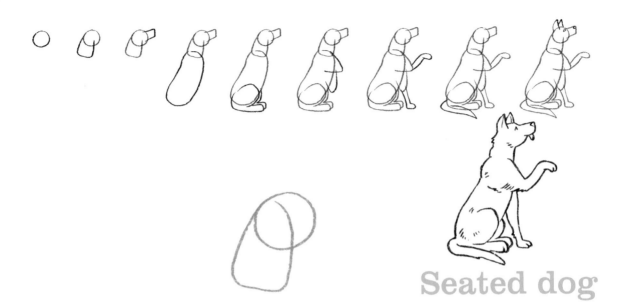

Seated dog

A dog is recognizable by its typical postures and movements, as well as its demeanor. To draw a seated dog, raise its head with the muzzle leading. The hind legs fold to assume the seated position and carry most of the weight; the front legs are for balance.

164th **day**

Weeping willow

Another way of drawing a tree is to start with the trunk and the branches. Then add details that identify the species; for a weeping willow, "hang" tufts of leaves on the branches, almost touching the ground.

165th **day**

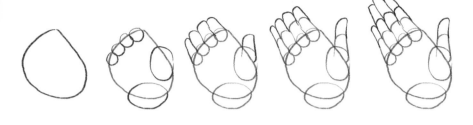

Twisted hand

In the case of a twisted hand, the movement mostly happens at the level of the wrist. The rest of the hand is practically unchanged.

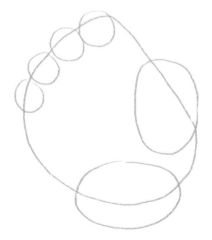

166th **day**

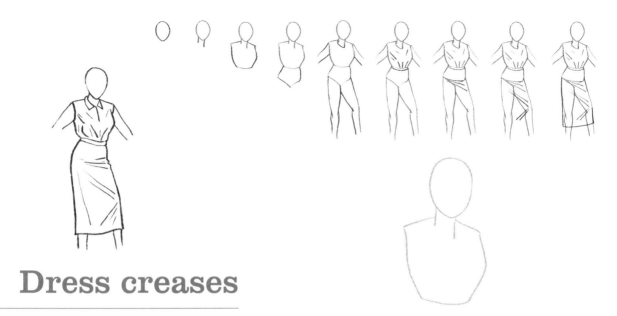

Dress creases

Smooth fabric will not crease if
it falls naturally, without tension.
When it is tightened or pulled
at, like it is here at the waist, it
pleats and creases at the chest.
The same occurs at the belly
under the tension created by
the bent knee.

167th day

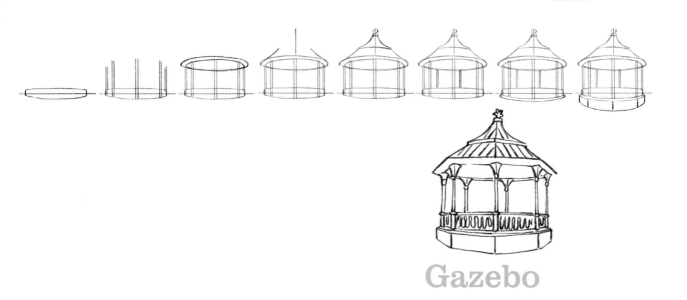

Gazebo

The basic shape looks like a cylinder. Each level, from the ground to the rail to the roof, is a circle in perspective. Seen from the top, it's below the horizon line; seen from the bottom, it's above it. These circles are then cut by straight lines to create the posts and railings.

168th **day**

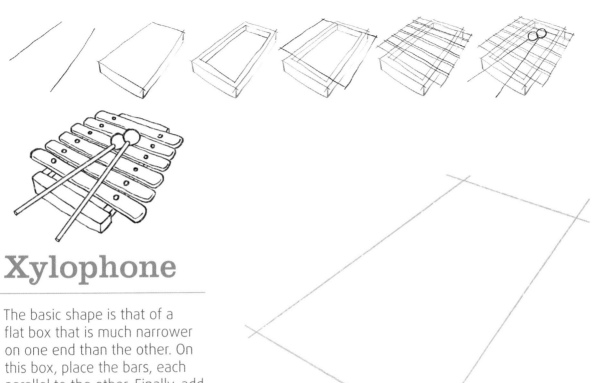

Xylophone

The basic shape is that of a flat box that is much narrower on one end than the other. On this box, place the bars, each parallel to the other. Finally, add the sticks.

169th **day**

Mountains

In a landscape drawing, it's important to bring out the feeling of depth. To do so, accentuate the details in the foreground while farther away, in the background, the scenery "fades" and less detail is visible. If too many details and strokes are added to the mountains in the rear, it will give the impression that these are in the foreground.

170th **day**

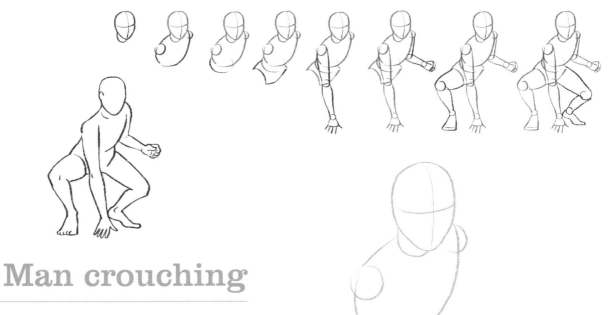

Man crouching

The lines of the torso, thighs, and calves move closer or farther away but still are in perspective. Thus, the parts shorten in relation to the starting proportions.

171st **day**

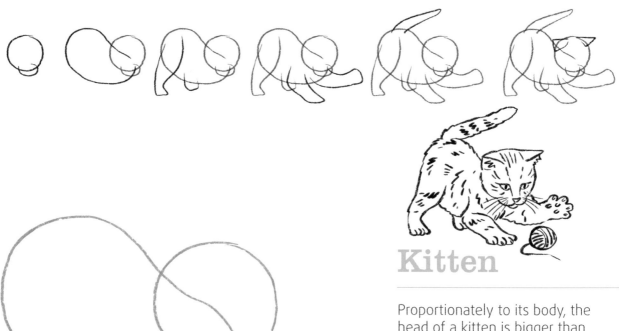

Kitten

Proportionately to its body, the head of a kitten is bigger than that of an adult cat. The legs are shorter, as well as the tail. But one constant is noticeable: the back of the body is always heavier than the front.

172nd day

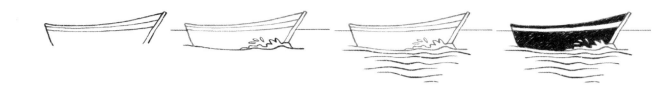

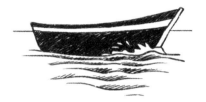

Boat

While sailing, the boat cuts the water and creates ripples and foam at its bow. The swell is stronger near the hull and calms as it distances itself. To make this effect even more visible, shade the inside of the waves.

173rd day

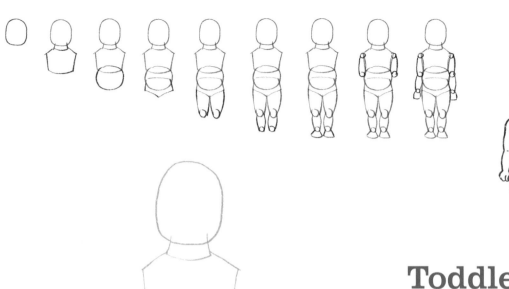

Toddler

Toddlers have lost some of their baby fat but are still curvy and chubby, especially the tummy. Draw a series of rounded shapes, starting with the head and ending with the feet, then add details like eyes, nose, belly button, knees and toes.

174th **day**

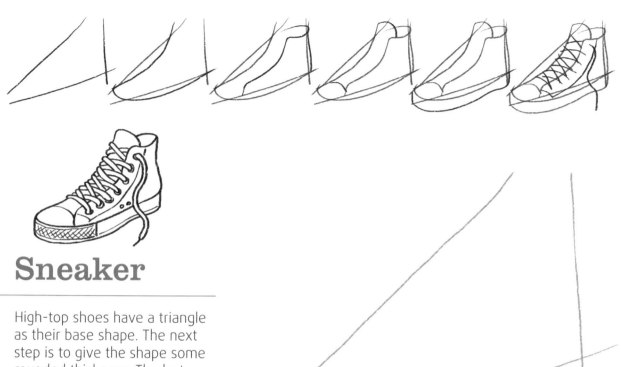

Sneaker

High-top shoes have a triangle as their base shape. The next step is to give the shape some rounded thickness. The last step is to add the details of the chosen shoe.

175th **day**

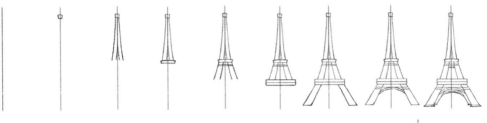

Eiffel Tower

The Eiffel tower has a very symmetrical and triangular shape. The different levels are built along a vertical line and end with the addition of the grid pattern. It's important to respect the symmetry to give it stability.

176th **day**

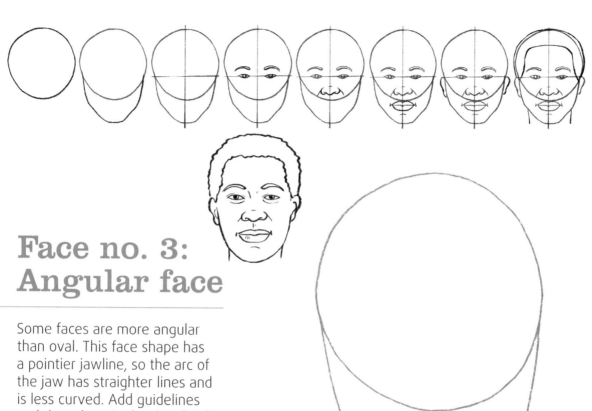

Face no. 3: Angular face

Some faces are more angular than oval. This face shape has a pointier jawline, so the arc of the jaw has straighter lines and is less curved. Add guidelines and then draw in the details of the face.

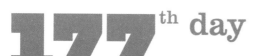

177th **day**

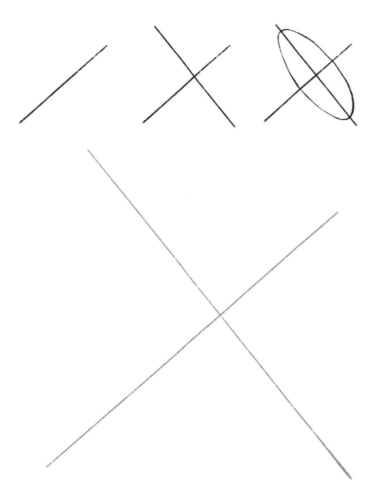

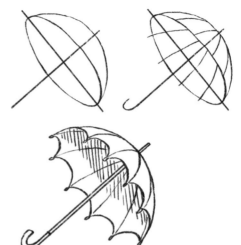

Umbrella

Open, the umbrella looks like a half-sphere poked onto an axis. Start with the handle by drawing a long line, then, perpendicular to it, draw another line to create the base of the half-sphere. This one, in perspective, looks like an oval dome and reveals the inside and outside.

178th day

Walking bear

Start with a big rounded shape for the body. The neck connects to the shoulders, and thins to meet the head, which is a small round ball. The muzzle is flat on top and the nose is small as is the eye. The paws are so covered with thick fur that it's not necessary to make the joints visible.

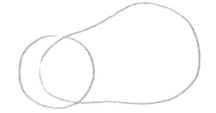

179th **day**

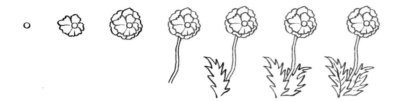

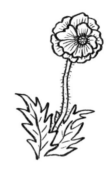

Poppy

The petals of the poppy center around two rows surrounding a small circle. They form small ripples since they are so fine and smooth. At the bottom of the stem, the leaves are very serrated.

180th **day**

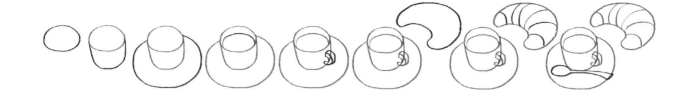

Coffee
and croissant

The cup is a small cylinder, therefore two circles connected by vertical lines. The saucer is a big circle. The whole is more or less oval depending on the incline in the perspective. The croissant is moon shaped; it's the curved lines that give it dimension.

181 st day

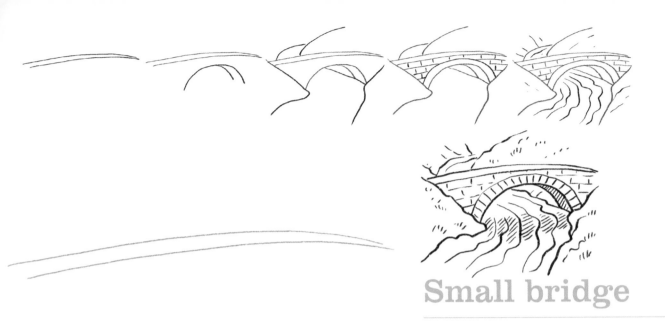

Small bridge

A small bridge is an arc covered by a small, slightly curved plateau. Add details such as the pattern of bricks to focus attention on the bridge, leaving the background vague. The bridge projects a shadow on the water that runs beneath it.

182nd **day**

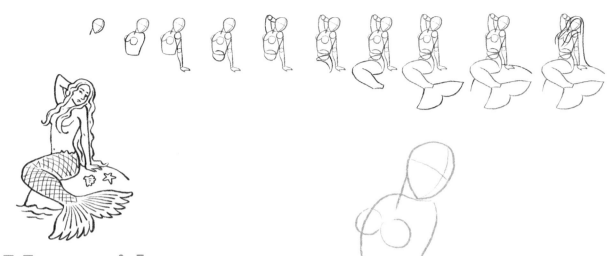

Mermaid

We associate the bust of a woman and the tail of a fish to be a mermaid. The tail takes the entire length of the legs to the waist. It's possible to fold the tail at knee level, as if legs were inside.

183rd **day**

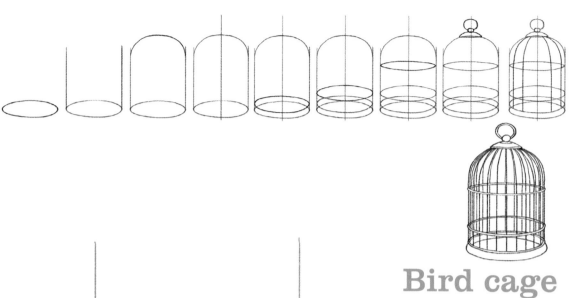

Bird cage

The base shape is a cylinder topped with a ball. As such, the straight lines end in curves towards the top. Draw the wires encircling the cage on the perspective, meaning they will be oval.

184th **day**

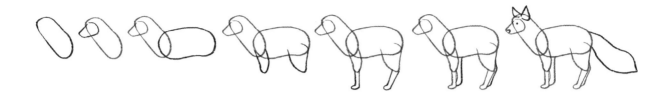

Fox

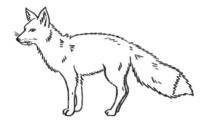

The fox is pretty small, more compact than the wolf. Its snout is a bit shorter and quite wide on the sides. A beautiful bushy tail and pointed ears make it easy to recognize.

185th **day**

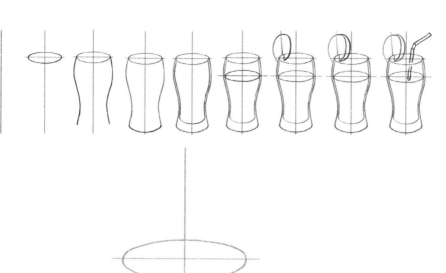

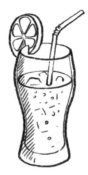

Glass of soda

Start with a glass in perspective. Continue by drawing long symmetrical vertical lines to create the two sides of the glass, in the chosen shape, and end with the rounded base. Finally, add the fizzy liquid and ice cubes.

186th **day**

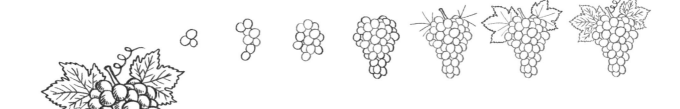

Bunch
of grapes

Be sure to superimpose the individual grapes in a disorganized manner until the general shape of the bunch of grapes is attained. Next step is to add the leaves and the details.

187th day

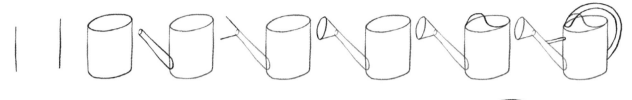

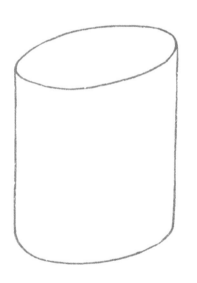

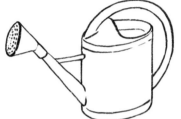

Watering can

The base shape is an oval cylinder. On either side, add the handle and the spout.

188th day

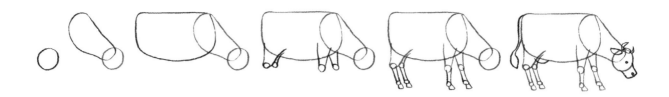

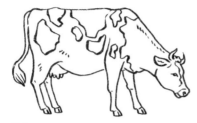

Cow

A cow's body is massive, heavy and rectangular in shape with a very large, rounded belly. Add the thick neck at an angle, and a round skull with a small, flattened snout. The horns attach on top, between the ears. Like a horse, the cow's legs end in hooves.

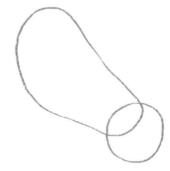

189th day

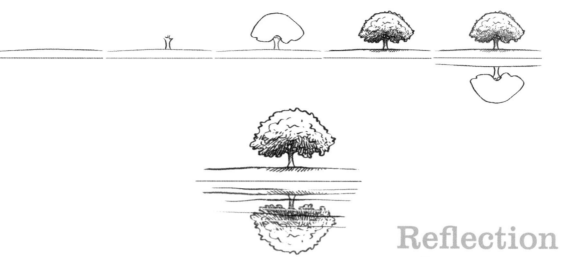

Reflection of a tree

When drawing something that reflects in water, start by drawing the object with all its details, and then reproduce its reflection upside down. The reflection will be much less detailed and unsettled by the movement of the water.

190th day

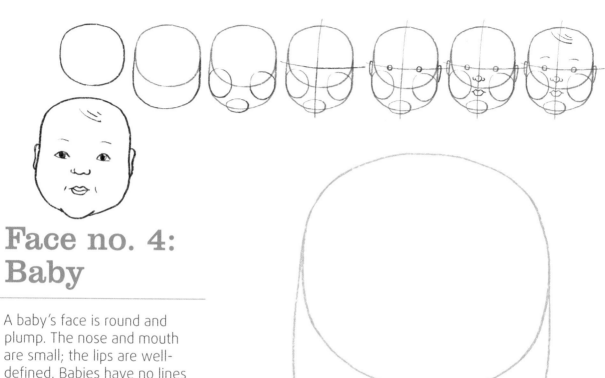

Face no. 4: Baby

A baby's face is round and plump. The nose and mouth are small; the lips are well-defined. Babies have no lines on their face other than when expressing feelings, like smiling or crying. Too many lines will end up looking like wrinkles; the more strokes we add, the more we age the face.

191st **day**

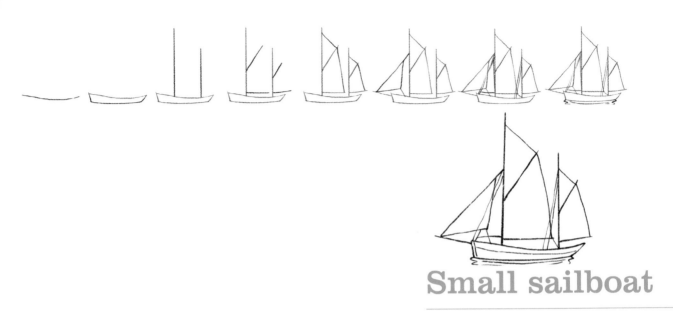

Small sailboat

Draw a simple barge and then add vertical masts and perpendicular lines. The final touch is the sails.

192nd **day**

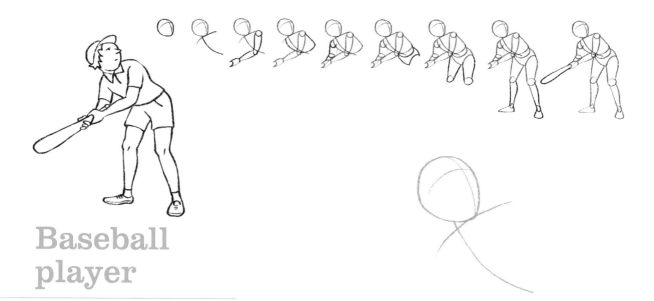

Baseball player

Ready to hit the ball, the legs and the player's back are a bit bent to give more flexibility. The gaze is in the direction of the trajectory, the arms and the bat ready to pivot the chest and hips around the axis of the body.

193rd **day**

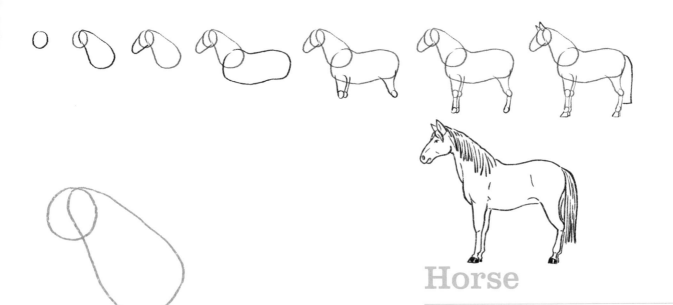

Horse

The massive body of a horse is supported by very long and lean legs. Its long neck ends with a narrow head characterized by the flat-topped snout and forward-pointing ears. When drawing the legs, it can be helpful to draw small circles to underline the articulation of each joint.

194th **day**

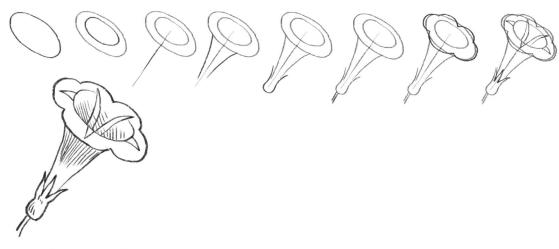

Morning Glory

The morning glory is shaped like a trumpet with five joined petals. The base of the horn is very fine and comes out of the bud of leaves. Don't forget to really show the cavity with the use of hatching to create shadows.

195th **day**

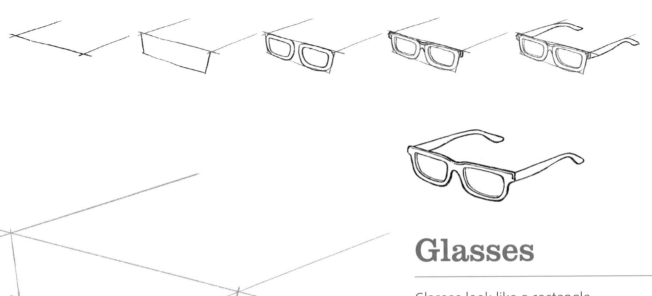

Glasses

Glasses look like a rectangle which has been divided to create both lenses in the desired shape.

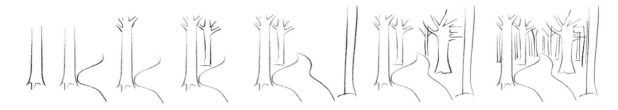

Forest trail

To give depth to a forest landscape, accentuate the details in the foreground that can be darkened and let the background breathe. The area deeper in the forest will have less detail.

197th **day**

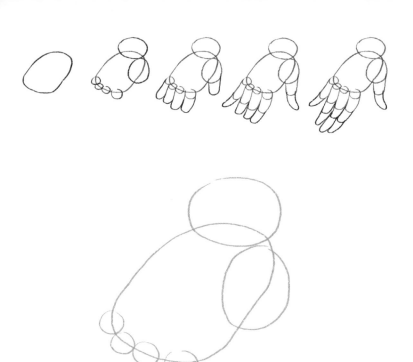

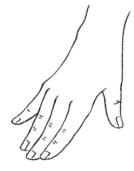

Delicate hand

To create a delicate demeanor, the fingers are slim, and the pinky finger is lifted slightly. The tips of the fingers arch a bit.

198th **day**

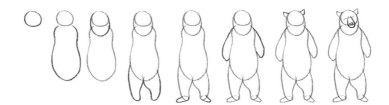

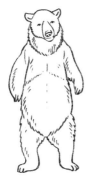

Standing bear

Imagine a stocky man: a big peanut shape for the body and a head connecte by a thick neck. Its legs are wide and solidly planted; there is no way this bear will fall over.

199th day

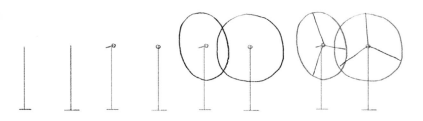

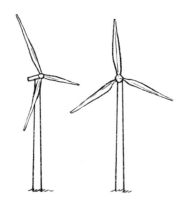

Wind turbines

Like the blades of a windmill, the blades of a wind turbine make a circle that turns around a central axis. Depending on where the viewer is, the circle is in perspective and is oriented on the axis and the foot.

200th **day**

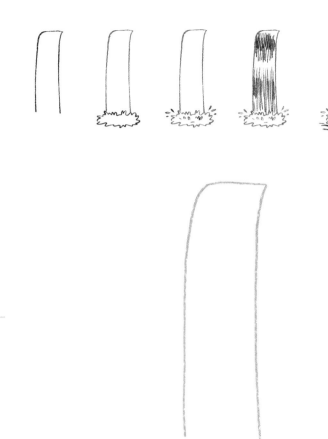

Waterfall

The very straight lines of a waterfall show that the water is falling quickly. This waterfall ends with a cloud of foam and splashes. On the surface of the water, the point where the waterfall ends can be shown by adding small, dark waves.

201st day

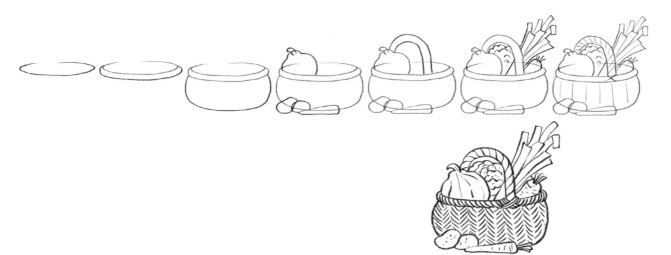

Gift basket

To draw a full basket, start by drawing the opening. Then add the bottom of the basket to give it volume. Finally, fill it with items, starting at the back, and add more outside the basket if desired.

202nd day

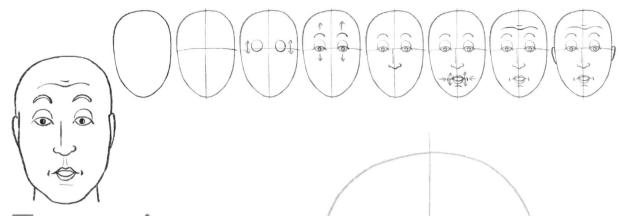

Expression: Surprise

In an expression of surprise, the most important aspects are the wide open eyes and the raised eyebrows, which cause the forehead to wrinkle. The mouth is more or less open.

203rd **day**

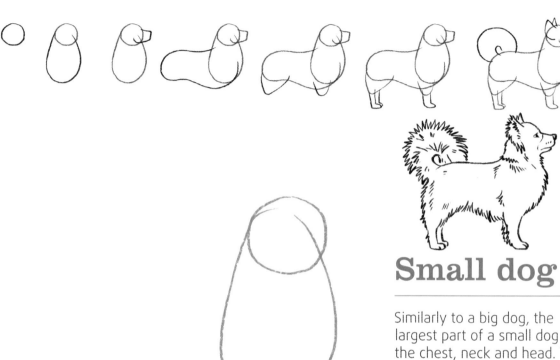

Small dog

Similarly to a big dog, the largest part of a small dog is the chest, neck and head. The legs and neck are short. In some breeds, the fur is so long that it "dresses" and changes the body's apparent size. Here the tail is curved and bushy.

204th **day**

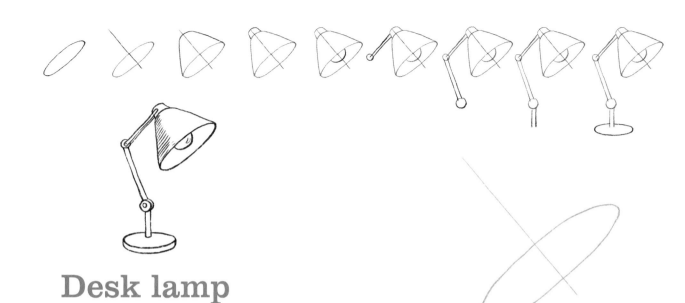

Desk lamp

The lampshade of a desk lamp looks like a cone that can be moved in many directions. Next, add the articulating arm and finish with the base, which is a circle in perspective and thickness.

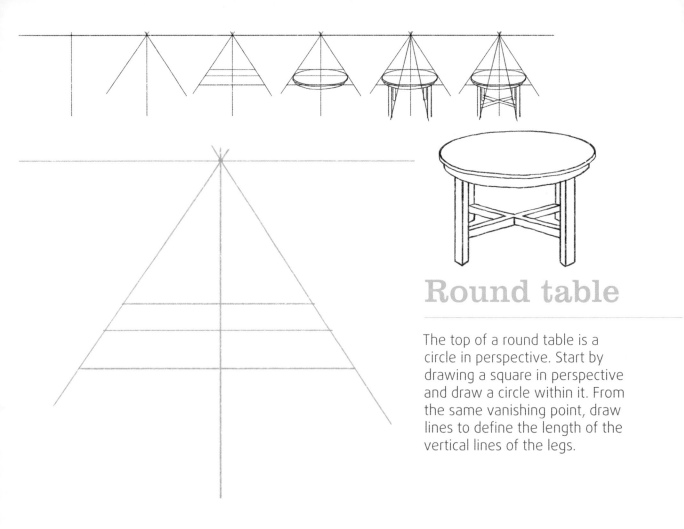

Round table

The top of a round table is a circle in perspective. Start by drawing a square in perspective and draw a circle within it. From the same vanishing point, draw lines to define the length of the vertical lines of the legs.

206th **day**

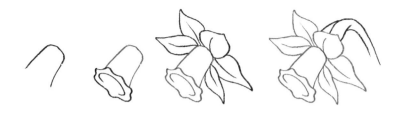

Daffodil

Start with the shape of a small bell. Then, with small wavy lines, draw the ruffled opening of the flower. This is the corona. Next, connect the corona to the six petals below it and finally to the curved stem.

207th **day**

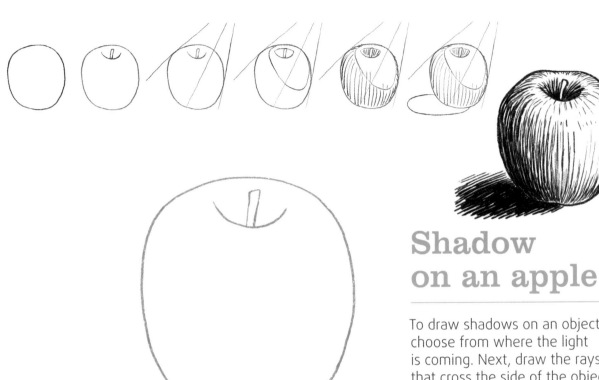

Shadow on an apple

To draw shadows on an object, choose from where the light is coming. Next, draw the rays that cross the side of the object. This reveals the areas where the light ends and the shadow begins. By continuing the lines of the rays, we obtain shadow on the ground.

208th **day**

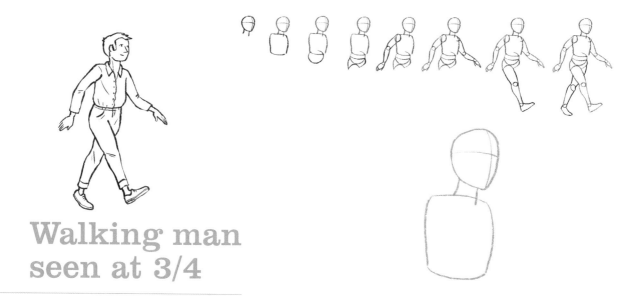

Walking man
seen at 3/4

To draw someone walking as
seen from a three-quarter view,
it is necessary to pivot the
entire body as if it were on a
pole. All of the horizontal lines,
the shoulders, and the hips are
in perspective.

209th **day**

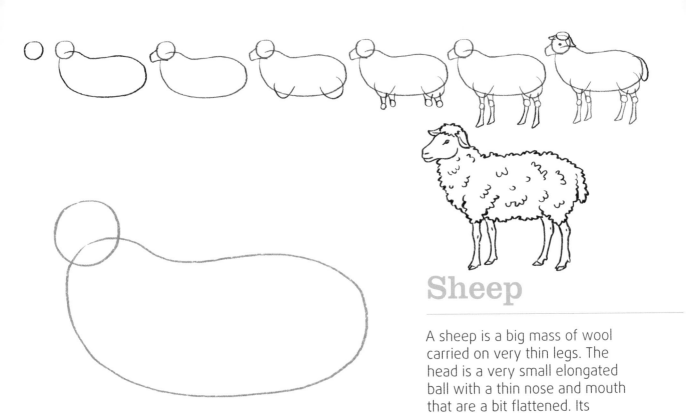

Sheep

A sheep is a big mass of wool carried on very thin legs. The head is a very small elongated ball with a thin nose and mouth that are a bit flattened. Its pointed ears fall to the side.

210th **day**

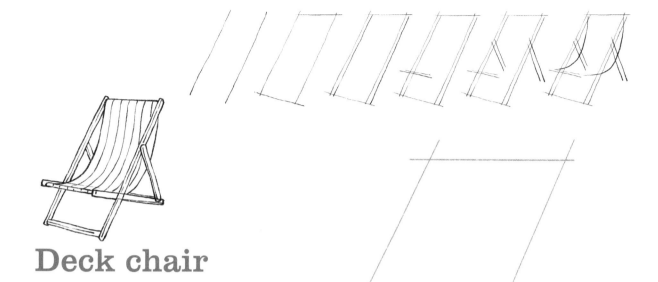

Deck chair

The main shape, which holds the cloth seat at the top, is an inclined rectangle. The two long lines, intersected by the seat frame, are parallel, and those at the top and bottom are in perspective. They separate only to rejoin near the horizon.

211th **day**

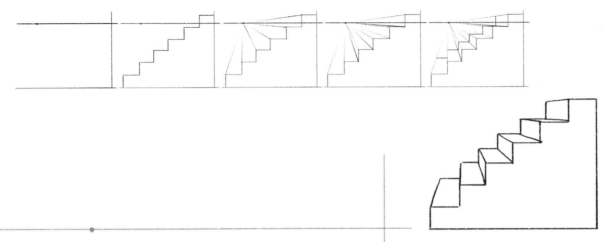

Stairs

Stairs must appear to be stable, which means drawing them using a vanishing point and perspective. Start with a straight side view. Add a vanishing point and as you "go up" the stairs drawing one step at a time, always refer to the vanishing point for the correct angle. The step risers are all vertical.

212th **day**

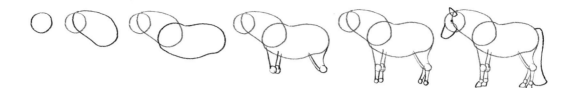

Pony

A pony is very small in comparison to a horse; it is much more compact, with a shorter muzzle and legs. Its mane, as well as its tail, can become very long and unruly.

213th day

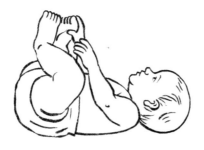

Baby on its back

A small baby often has its legs bent and spread apart; the shapes are all rounded and plump. Babies are very flexible.

214th **day**

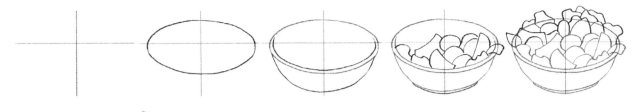

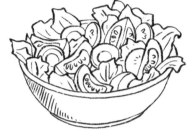

Bowl of salad

To draw a full bowl, start with a circle in perspective to create the opening. Add a semi-circle that is more or less round; this is the bottom of the bowl. Finally, fill the bowl starting with the elements in the foreground.

215th day

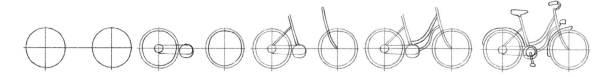

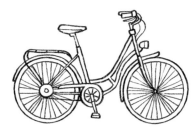

Bicycle

A bicycle is an ensemble of components attached to a frame that "floats" between the two wheels, with a near-vertical frame for the rider. Start with the wheels then add the elements and their details, depending on the type of bicycle.

216th **day**

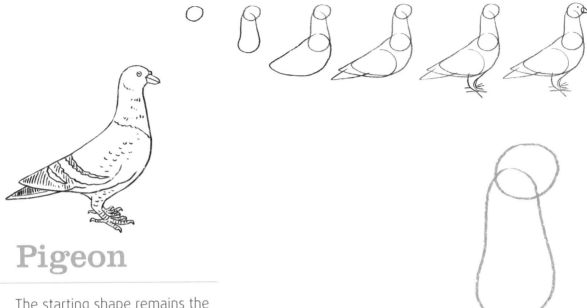

Pigeon

The starting shape remains the same as that of a small bird, but more elongated. Add the long neck narrowing from the body to the small head. The wings and the tail are gathered the length of the body and end in a point.

217th **day**

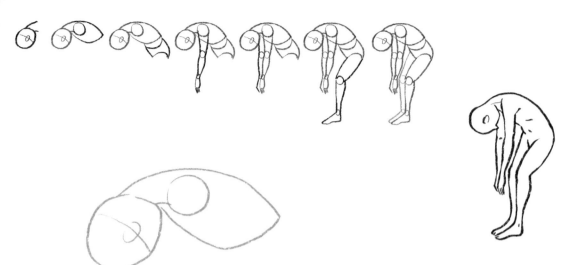

Sadness

To draw a character that is sad, in the same way you would for a face, use the principle that everything falls downwards. As such, curve its back and lower the arms and the head.

218th **day**

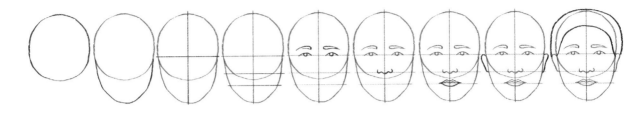

Face no. 5: Hair

In addition to the shape of a person's head, the hair (or lack of) and features, like eyebrows, a mustache, a beard or sideburns, help to create a recognizable portrait.

219th **day**

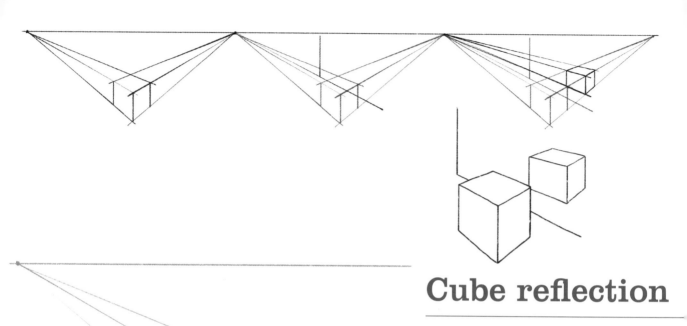

Cube reflection

Drawing the cube and its reflection relies on the vanishing lines and perspective. Use two lines to create the "mirror." The farther the cube is from the mirror, the smaller is its reflection.

220th **day**

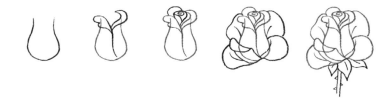

Rose in profile

The rose is built as a spiral. Near the center, the petals are tight, and towards the outside, they are bigger and start to curve.

221st day

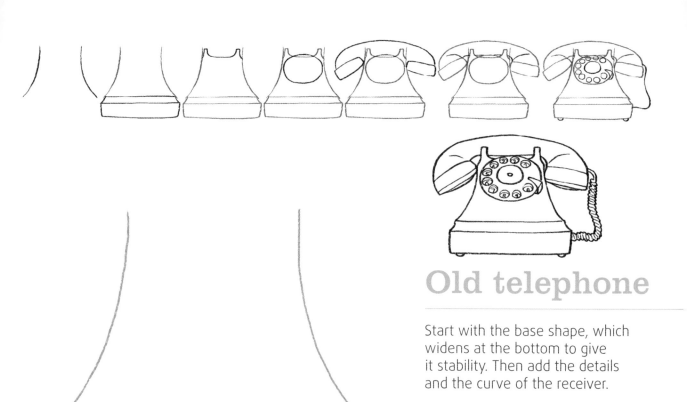

Old telephone

Start with the base shape, which widens at the bottom to give it stability. Then add the details and the curve of the receiver.

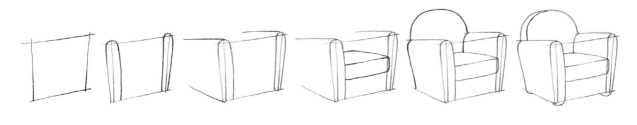

Armchair

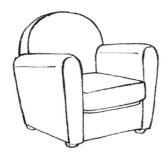

The base shape is a big cube with a rounded backrest. Start with a rectangle and then create depth by adding lines showing the thickness of cushions and the rounded edges of the arms.

223rd day

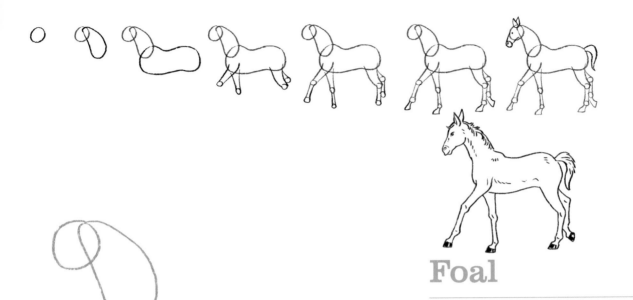

Foal

A foal resembles a horse, of course, but is thinner and more delicate. It can even be a bit skinny. Its mane and tail are less lush and orderly than those of a horse. It's also its joyous attitude that makes it easily identifiable.

224th **day**

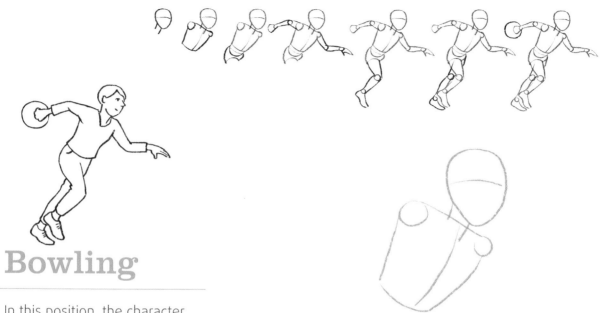

Bowling

In this position, the character projects itself forwards, leaning to create a counterweight to the ball. Similarly to walking or running, the right arm goes forwards at the same time as the left leg, and vice versa.

225th **day**

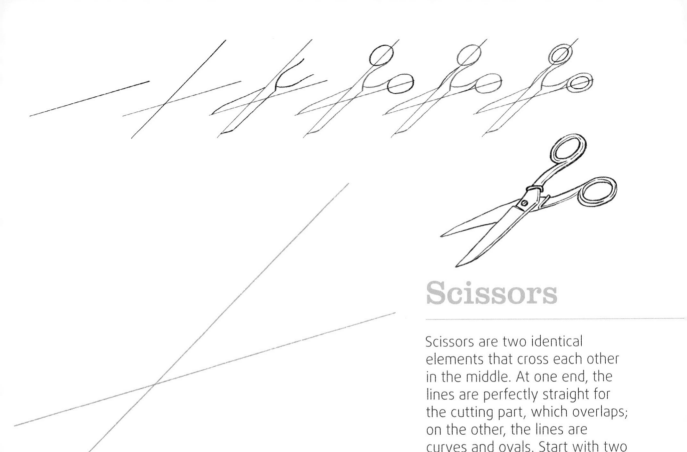

Scissors

Scissors are two identical elements that cross each other in the middle. At one end, the lines are perfectly straight for the cutting part, which overlaps; on the other, the lines are curves and ovals. Start with two crossed lines and add details from the axis.

226th day

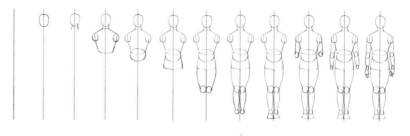

Man from the back

From the back, the silhouette looks the same as from the front. Drawing in the muscles changes this: the nape of the neck, the shoulder blades, the kidneys, the buttocks, the elbows, the back of the knees, and the ankles.

227th day

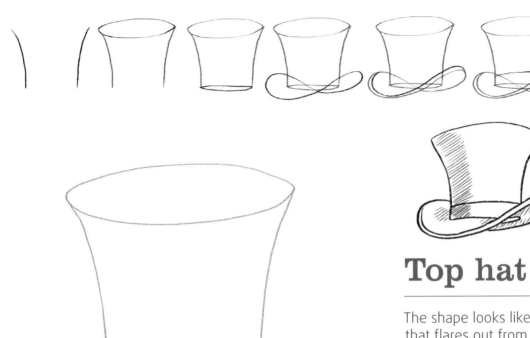

Top hat

The shape looks like a cylinder that flares out from bottom to top. The top of the hat is a circle in perspective. The brim is smooth and in the shape of a flat circle in perspective, which has been bent, but: viewing from one side the top can be seen, and from the other, the underneath.

228th **day**

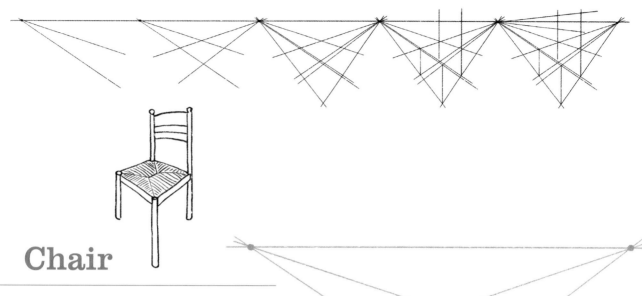

Chair

Place two vanishing points on a horizon line. From the first point, draw two lines. From the second point, do the same thing but in the opposite direction. This reveals the seat between the crossing lines. Draw two new sets of lines from the vanishing point above and below the existing lines to get the height of the backrest and the length of the legs. Vertical lines reveal the chair in entirety.

229th day

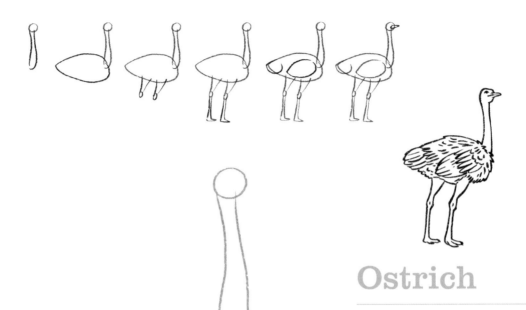

Ostrich

An ostrich resembles a flamingo but with a shorter, less curved neck. It too has a big body in the shape of a flat-bottomed dome, rounded towards the chest and pointed towards the tail. It is mostly recognized because of its long neck topped by a very small head, as well as by its long muscular legs.

230th **day**

Gondola

The base of a gondola is a very elongated barge on which the bow and the stern are stretched and carved. It's important to give the impression of stability while maintaining its characteristic design, decoration and delicateness. The last step is to add reflections in the water and to darken the hull.

231st **day**

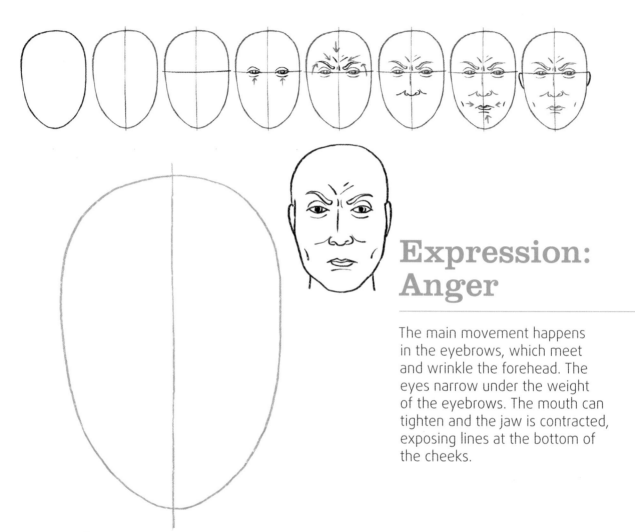

Expression: Anger

The main movement happens in the eyebrows, which meet and wrinkle the forehead. The eyes narrow under the weight of the eyebrows. The mouth can tighten and the jaw is contracted, exposing lines at the bottom of the cheeks.

232nd day

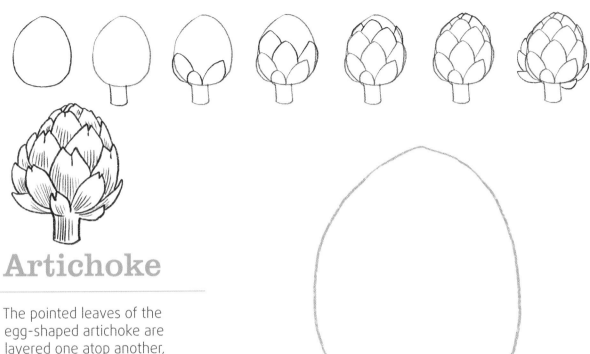

Artichoke

The pointed leaves of the egg-shaped artichoke are layered one atop another, smaller in the heart to larger on the outside. The whole is attached to a thick stiff stem. If looked at from above, the leaves of an artichoke make a spiral.

233rd **day**

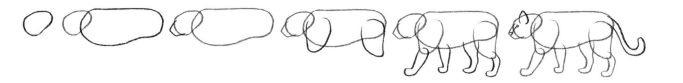

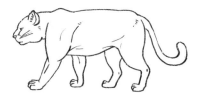

Jaguar

A jaguar is a large, muscular wild cat with a nature and movements that are typically feline. Its paws are large, the head slightly flattened, its ears almost circular and its tail flexible and long.

234th **day**

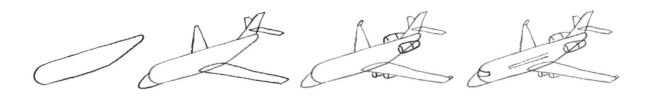

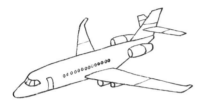

Airplane

To draw a jet plane, start with a type of narrow tube with a level top and narrowing at one end, slightly upwards. The other end is a ball shape. The wings attach at a sharp backward angle while the rudder/stabilizer unit is mounted on the narrow end and above two engines. Two of the four other engines are visible, mounted below a front wing.

235th **day**

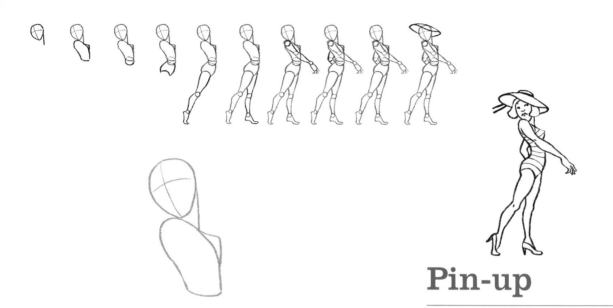

Pin-up

It is the pose that characterized the once-popular pin-up photos. Meant to be seductive, the back is arched, the arms and legs stretched and posed, and the heel flirtatiously lifted.

236th **day**

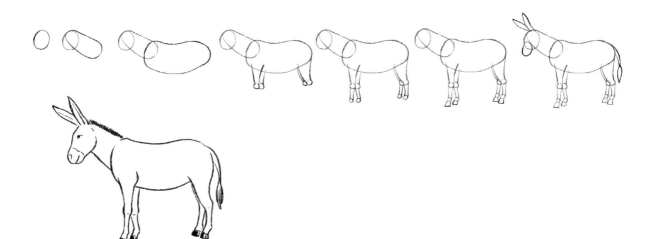

Donkey

A donkey has shorter legs than a horse. It's squatter and less elegant. Its nose is wider and rounder, and its ears longer. Its mane and tail are thinner, and its body is stocky and less muscular.

237th **day**

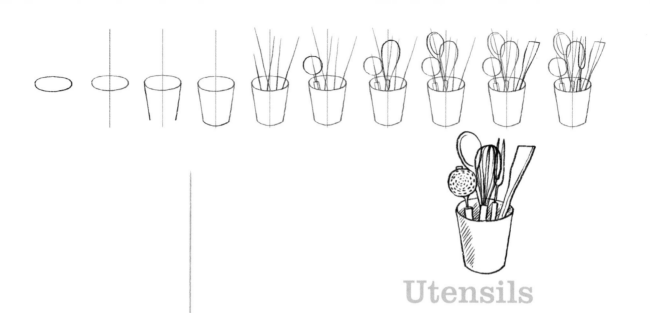

Utensils

Start with the pot. It looks like a slightly flared cylinder. The next step is to fill the pot with lines that are more or less tilted, and finished to look like various utensils. The final step is to add shadows on the inside and outside of the pot.

238th **day**

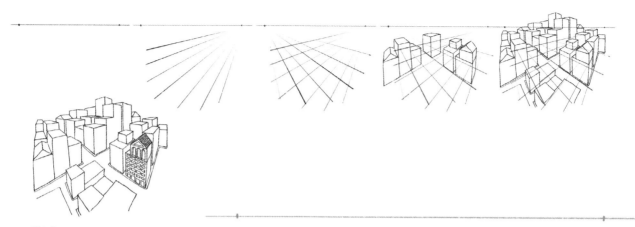

City
from above

Draw a web of vanishing lines from two points on the horizon, going towards the bottom. Next, draw vertical lines to place boxes on these intersections to create the buildings. The vertical lines are all perpendicular to the horizon line. The last step is to add details to the buildings.

239th day

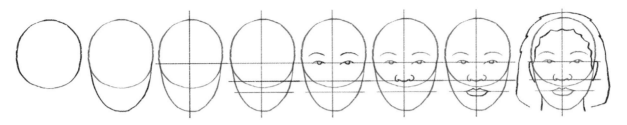

Face no. 6: Shade and texture

After drawing a face, you can add lines to convey light, shade and texture. This helps the drawing appear more lifelike, with greater depth and dimension.

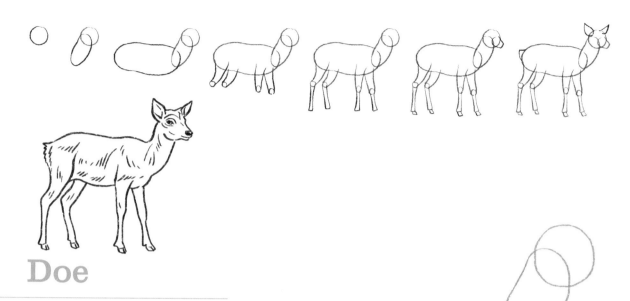

Doe

A doe is very delicate. Her legs are thin with small hooves. Her nose and mouth are quite pointed. She has long flared ears. The tail is only a small feather duster.

241st **day**

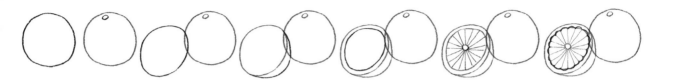

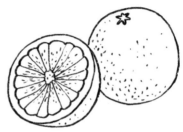

Orange

The particularities of an orange are found in its rough peel, its color, and finally, in the floral organization of its segments when it is cut crosswise. Lengthwise of course reveals a different pattern.

242nd **day**

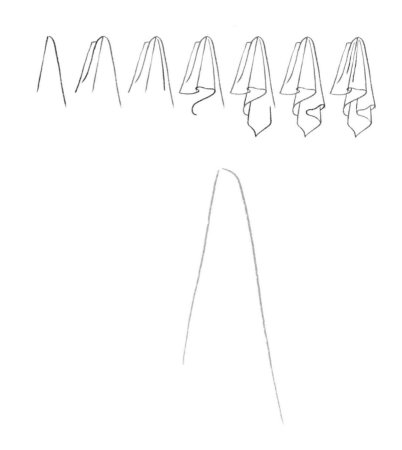

Shadows
on fabric

Shadows are a simple way to create depth, wrinkles and folds, as found in fabric. Start by drawing the fabric in a heavily pleated shape. Next, choose the orientation of the light and imagine which parts will be in the shadows. Certain shadows are stronger than others.

243rd day

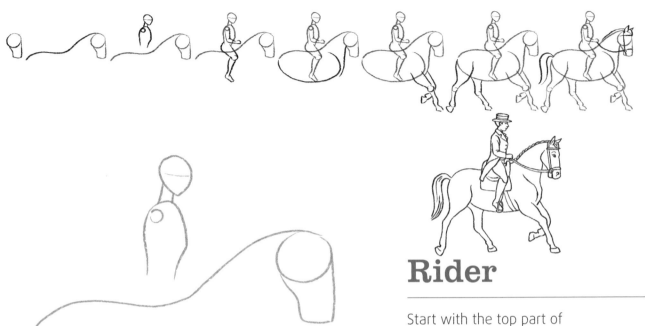

Rider

Start with the top part of the horse and add the rider. Let them progress together, comparing proportions as you go. Horses' feet hit the ground in a different order depending on speed. This drawing shows a trot footfall: right front/left hind, left front/right rear.

244th day

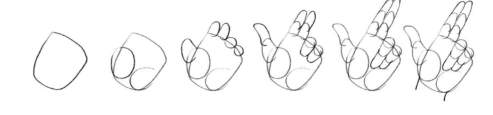

Closed hand

To draw bent fingers, fold the phalanges (end sections) towards the palm and draw the nails of these fingers. Lines show the knuckles.

245th **day**

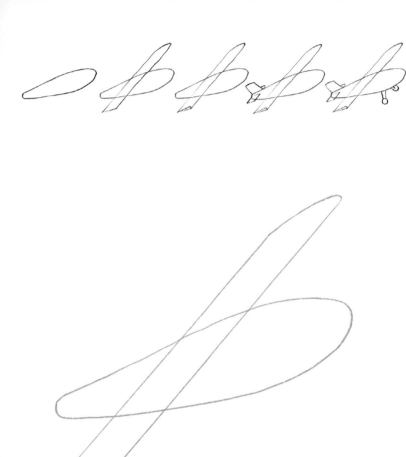

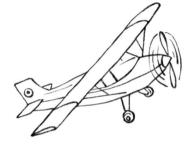

Small airplane

The base shape is more tapered at the back, and more rounded at the center front, or "belly." Whatever the direction or incline of the airplane, the wings are always mounted perpendicularly. Finish with the details.

246th **day**

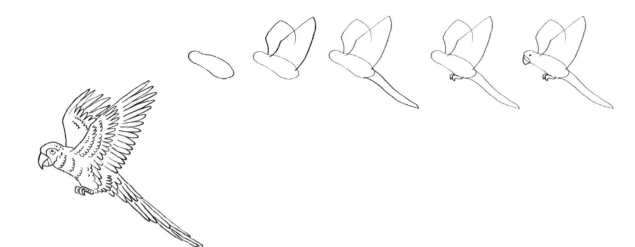

Parrot

The parrot is a bird that is quite elongated. It is primarily characterized by its very long tail, its round and hooked beak, and of course, its multiple colors. Its wings, when deployed, form a big fringe of long feathers.

247th day

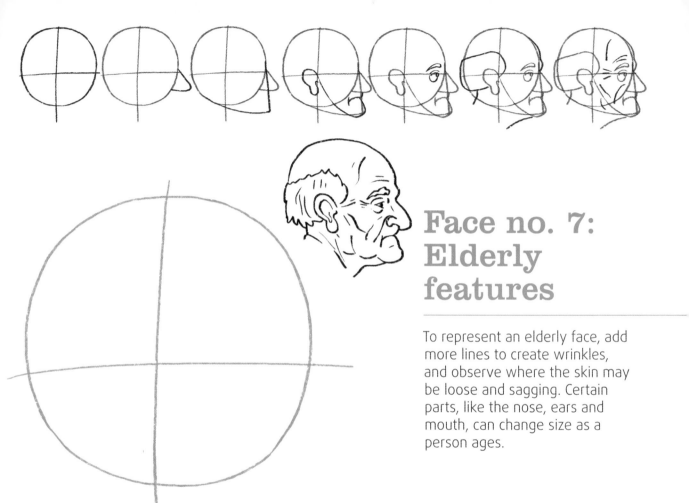

Face no. 7: Elderly features

To represent an elderly face, add more lines to create wrinkles, and observe where the skin may be loose and sagging. Certain parts, like the nose, ears and mouth, can change size as a person ages.

248th **day**

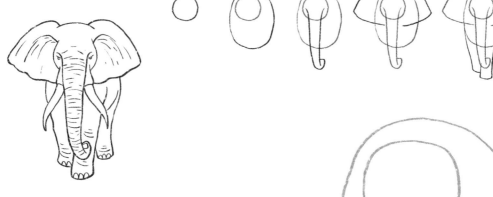

Elephant face

The roundish head of an elephant is very small compared to the enormous butterfly ears. The long, thick trunk starts between the small eyes and drops between the tusks, narrowing towards the ground. An elephant's large feet have thick round nails.

249th **day**

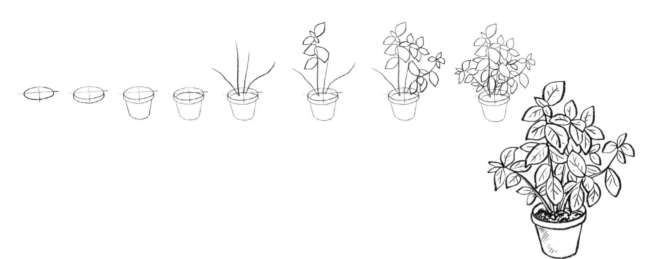

Potted plant

Start by sketching the pot which looks like a flared cylinder. Add smooth lines for the stems, spacing them further apart as they get to the top of the plant. Next, dress the stems with leaves by putting the emphasis on those in the foreground.

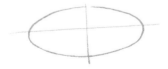

250th **day**

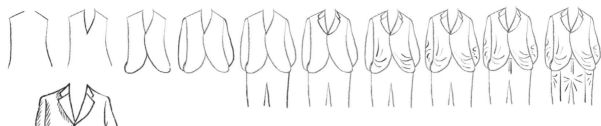

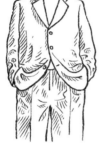

Loose fabric

A loosely-fitting blazer and pants made of a light fabric are going to form lots of creases as they sit on the body. Avoid drawing lines that are too straight, angled or rigid, and then add folds and shadows, primarily where the fabric would fall or fold or gather, such as, in the crook of the elbows.

251st day

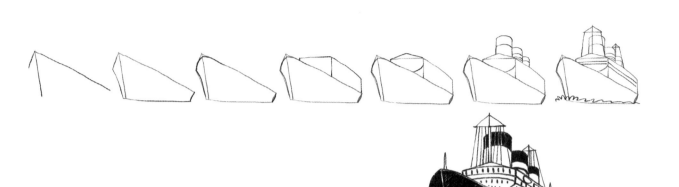

Ocean liner

The shape of a three-quarter view of an ocean liner in perspective is a triangle with the sharpest angle at the front bow. The hull narrows to the rear to square off for the stern. Keeping the same perspective to a vanishing point, draw another level atop the hull, set back from the bow and rounded. Top it with smokestacks and add waves to indicate water.

252nd day

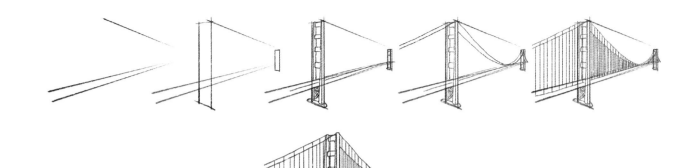

Suspension bridge

Sketching a long bridge is all about perspective. Consequently, all the lines are going to be directed towards a vanishing point on the horizon. The back end of the bridge will be much smaller than the foreground.

253rd **day**

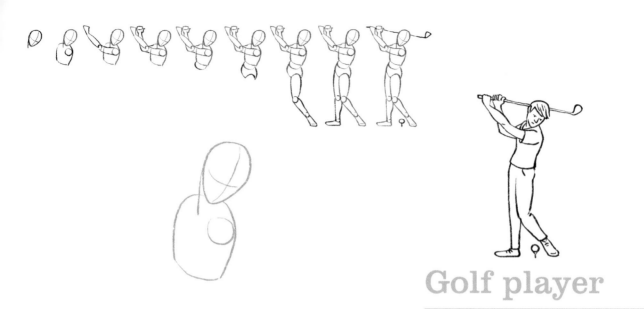

Golf player

In this position, the body of the character undergoes a twist. Its feet are almost facing us, while the top of the body is completely turned in profile.

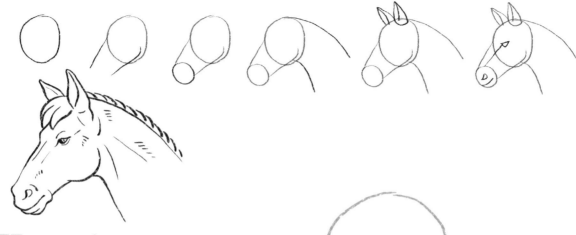

Horse's head

Start with two circles in perspective, one slightly larger than the other. Join them with straight lines and then add two curved lines for the neck. The larger circle is the head and cheeks with the ears on top. The smaller end is the nose, slightly rounded, with the nostril and mouth.

255th **day**

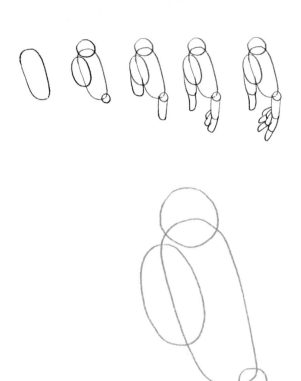

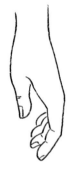

Hand in profile

In profile, the hand looks flat;
the fingers appear one behind
the other, and the thumb
underneath.

256th **day**

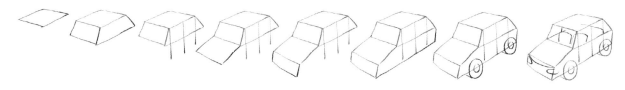

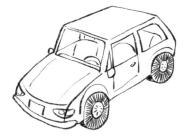

Small car

To draw a car at a three-quarter angle seen from above, start with the prominent shapes: the square and rectangle hood, glass and top of the car. Add vertical lines for doors and a horizontal line to close up the image. Wheels and details are last.

257th day

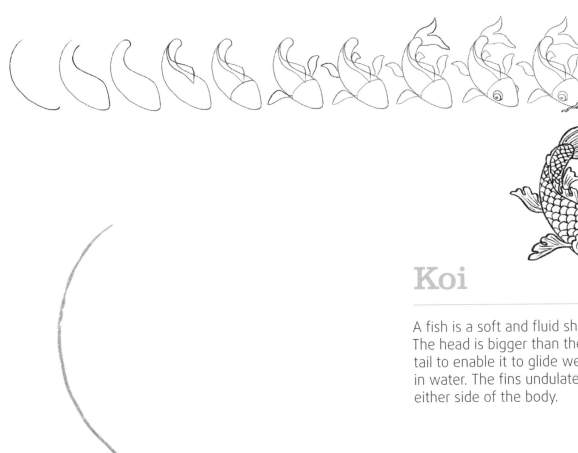

Koi

A fish is a soft and fluid shape. The head is bigger than the tail to enable it to glide well in water. The fins undulate on either side of the body.

Foxglove

Start with the long stem and then add the small bells. Those at the bottom are bigger than those at the top. At the very top, they are only buds.

259th **day**

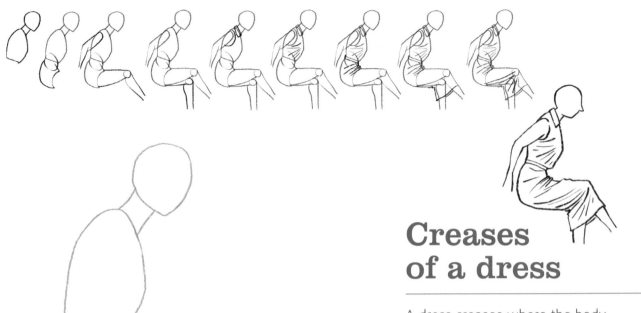

Creases of a dress

A dress creases where the body bends: the arms, the waist, the knees; but equally where body parts exert pressure: across the chest, the hips, the crossed legs...

260th **day**

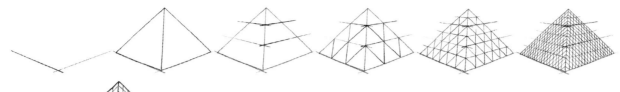

The Louvre Pyramid

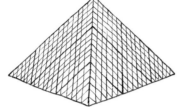

Start with two angled triangles. Then, on either side of it, add the vanishing lines to enable the drawing of the grid pattern in a proportionally exact and stable manner.

261st **day**

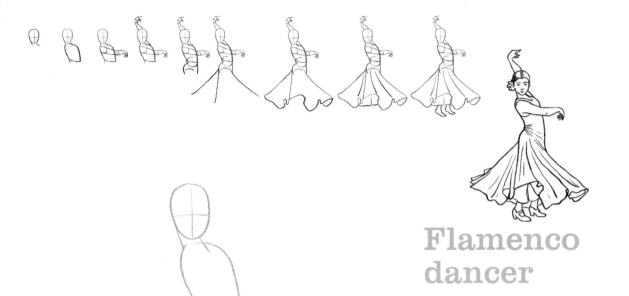

Flamenco dancer

The position is energetic; the body is twisted and wiggles. The skirt is so voluminous that it's not necessary to draw the legs, unless there is doubt regarding the proportions of the body and that there is a risk of shortening the lower body parts.

262nd **day**

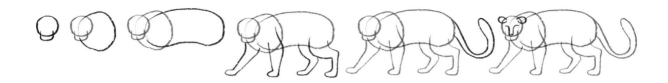

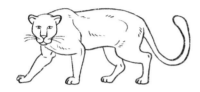

Panther

By stretching and making a cat bigger, all feline species can be represented. The weight of the panther's body leans slightly towards the front, the muscles develop and become more visible. The paws are bigger.

263rd **day**

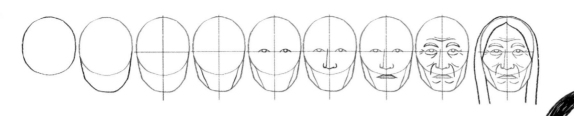

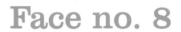

Face no. 8

Sometimes a person will wear clothing and accessories to express their personality or reflect their heritage. Drawing the face, however, still relies on the same principles, such as the rule of thirds.

264th **day**

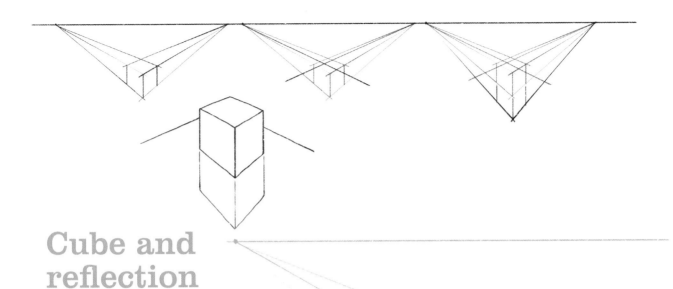

Cube and reflection

If the mirror is placed on the ground under the cube, the reflection is going to be subject to the same perspective as the object.

265th **day**

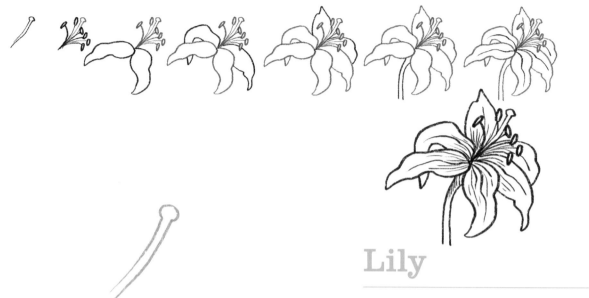

Lily

The lily has six big petals, long and smooth, that encircle a large pistil and six stamens topped with small seeds.

266th **day**

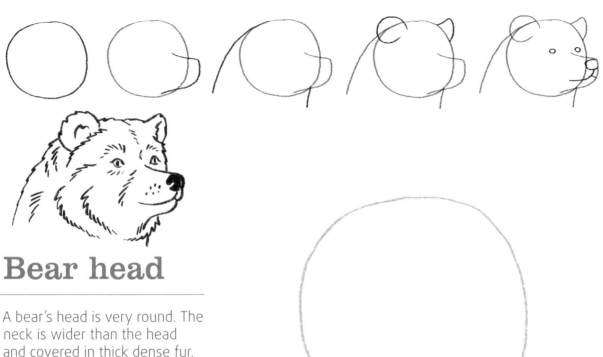

Bear head

A bear's head is very round. The neck is wider than the head and covered in thick dense fur. The muzzle is elongated with a flat top down the snout and at the end is the nose. The eyes are small and the ears round.

267th day

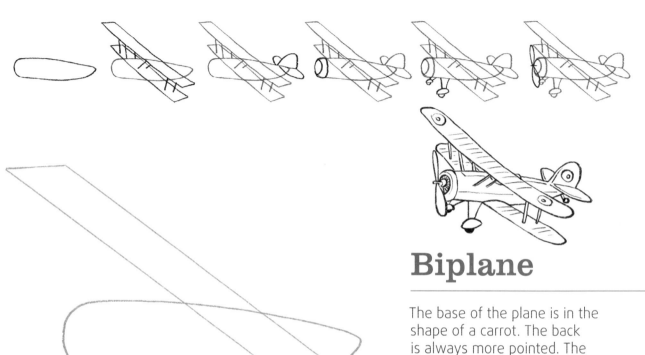

Biplane

The base of the plane is in the shape of a carrot. The back is always more pointed. The parallel wings are attached at the top and bottom of the base. The wings show the incline of the plane, as do the rear wings.

268th **day**

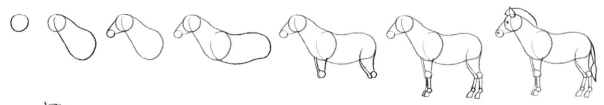

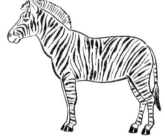

Zebra

The zebra, a bit smaller than the horse, is remarkable due to its stripes. Its mane stands up like a ridge. The tail is like a striped rod that ends in a tuft of horsehair.

269th **day**

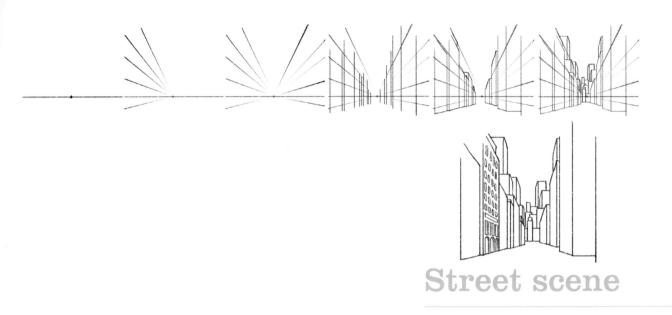

Street scene

When looking at a city from the ground, positioned in the middle of the street, the vanishing lines radiate mostly towards the top, towards a central point on the horizon. Very few lines cross under the horizon. The biggest buildings are placed on the lowest lines. The verticals remain perpendicular to the horizon.

270th **day**

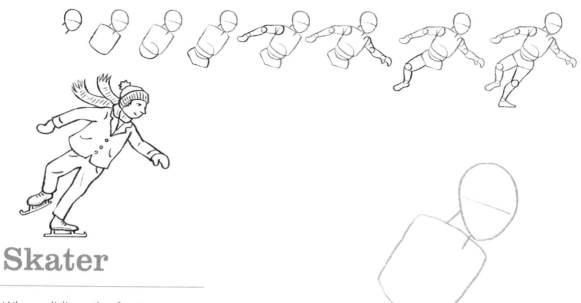

Skater

When gliding, the feet can turn to change direction and make the legs and body turn. The whole body leans forwards in order to maintain balance. The arms are spread out and act as a counterweight.

271st **day**

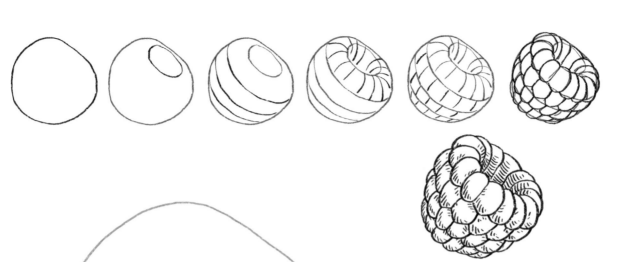

Raspberry

A raspberry has an overall
rounded shape, filled with
many small balls, tightly packed
in rows. As the balls spiral
downwards they get smaller.

272nd **day**

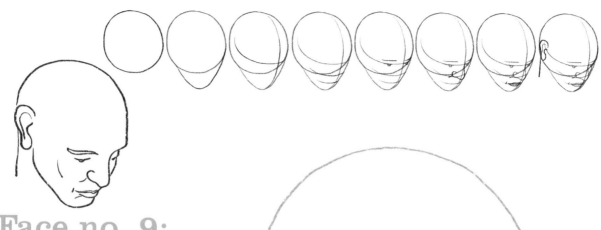

Face no. 9: From above

The size and volume of the skull compared to the face is especially noticeable when seen from a three-quarter view. The eyebrows and nose are prominent and the mouth is almost hidden by the angle of view. The three horizontal guiding lines all curve downwards.

273rd **day**

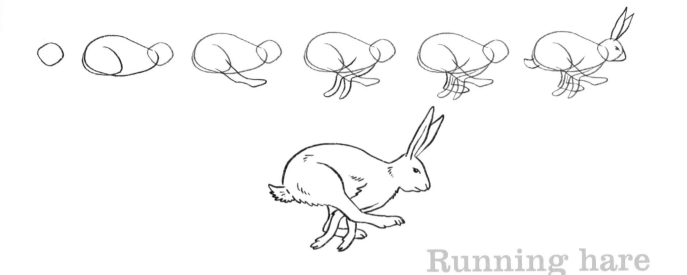

Running hare

A running hare stretches and elongates itself. It's a bit more angular than a rabbit which is very rounded, especially in the rear; the hare is sleek and slim. The faster it runs, the more its legs cross. Its ears are quite long and its muzzle pointed.

274 **th day**

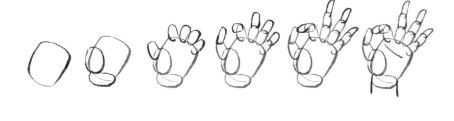

Hand

Like the body, the hand is composed of articulating shapes. When drawing a hand, it's difficult to keep a proportional balance between the numerous parts while achieving the correct movement and angles.

275th **day**

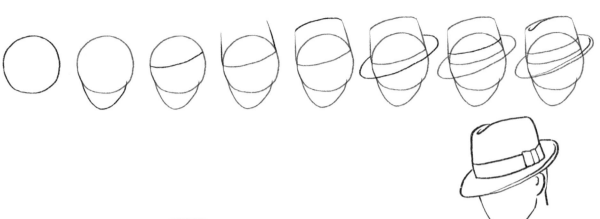

Classic hat

Start with a round for the head and add an arc for the jaw. Draw the squarish crown which sits on the head as viewed from the side and above. Draw a band for the brim with another line next to it for the brim edge.

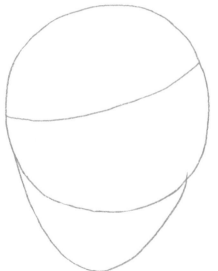

276th **day**

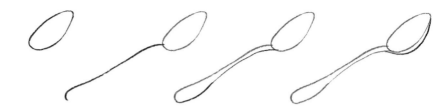

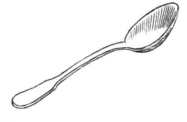

Spoon

A spoon is drawn along
a straight line. The shape
undulates on this line, towards
the top and towards the
bottom. In spite of its curves,
it's important to keep the
impression of a straight line
otherwise it will feel like the
spoon is twisted.

277th day

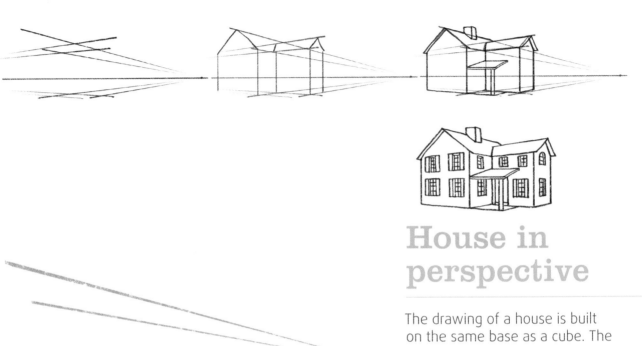

House in perspective

The drawing of a house is built on the same base as a cube. The vertical lines are perpendicular to the horizon, the horizontal lines moving towards two vanishing points.

278th **day**

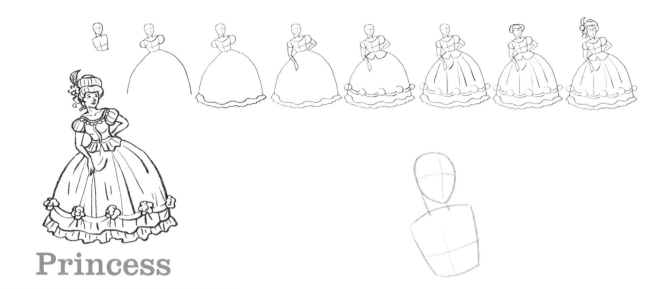

Princess

The details are what's important here: the dress and its embellishments. Since the skirt is voluminous, the legs are not seen, so make sure the body proportions are accurate.

279th **day**

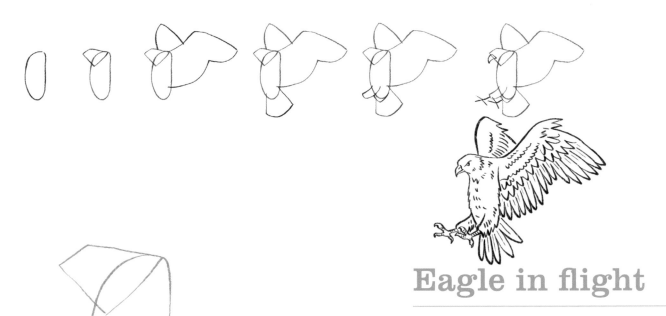

Eagle in flight

The starting shape is kind of like an oval, topped by an angular head. The wings are attached to the shoulders and end in a multitude of very visible pointed feathers. Don't forget the flared tail, big angular beak and the impressive claws.

280th day

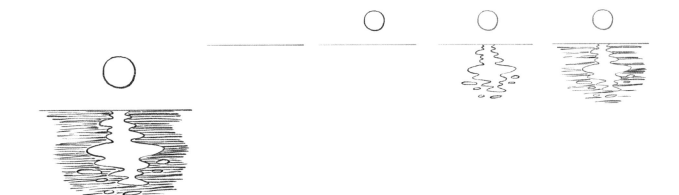

Sunset

Even calm, the sea is in motion. As such, the reflection of the sun will be sinuous. Start by drawing the horizon line and the sun. Next, draw the sun's reflection in the water: a wavy and elongated shape. Finally, darken the sea all around.

281st day

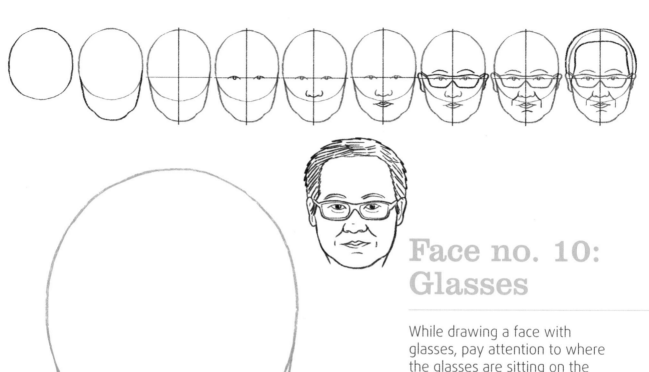

Face no. 10: Glasses

While drawing a face with glasses, pay attention to where the glasses are sitting on the face and the proportions of the frames relative to the eyes. Also pay attention to the shape and thickness of the frames.

282nd day

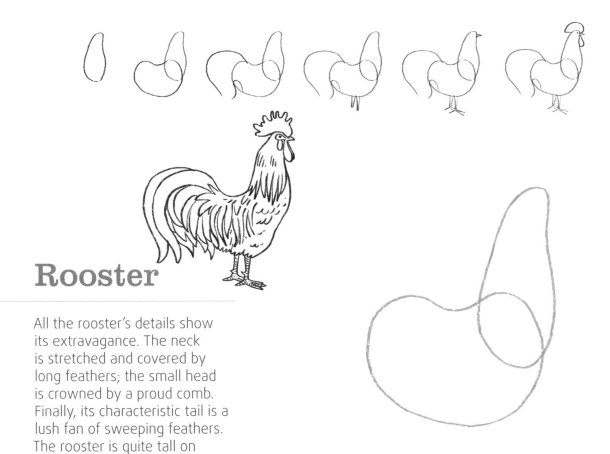

Rooster

All the rooster's details show its extravagance. The neck is stretched and covered by long feathers; the small head is crowned by a proud comb. Finally, its characteristic tail is a lush fan of sweeping feathers. The rooster is quite tall on its legs.

283rd **day**

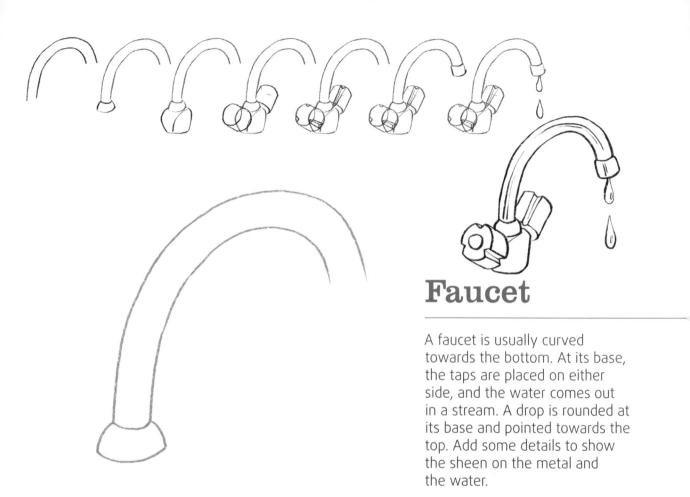

Faucet

A faucet is usually curved towards the bottom. At its base, the taps are placed on either side, and the water comes out in a stream. A drop is rounded at its base and pointed towards the top. Add some details to show the sheen on the metal and the water.

284th **day**

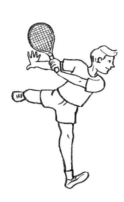

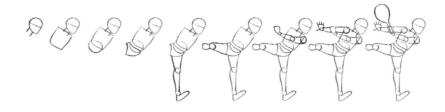

Tennis player

In this position, the tennis player has his chest facing out, while one leg is turned towards the front and the other is bent, making the calf and a part of the foot invisible.

285th **day**

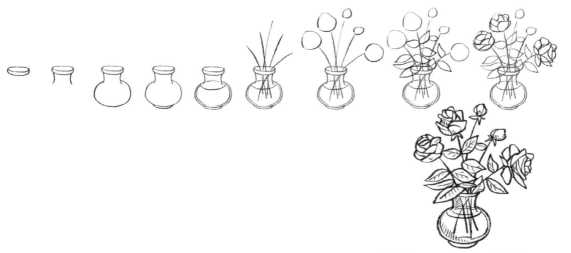

Vase of flowers

Start with the vase opening, an oval, and work downwards. Once the water curve is added, you can see that the vase is transparent. Add the supple stems that are topped with shapes for the flowers. The last step is to add details to the flowers and draw the leaves.

286th day

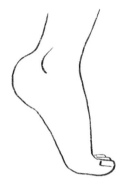

Tiptoe

The foot itself cannot bend, only
the ankle and toes. On tiptoe,
the toes bend to take the
weight, the heel goes up and
the ankle straightens.

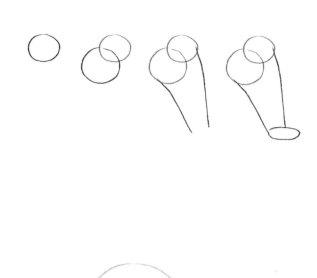

287th **day**

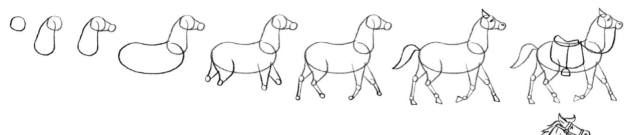

Trotting horse

A trotting horse doesn't move the front and back legs at the same time: if it moves the right leg forwards, it will move the left back leg at the same time.

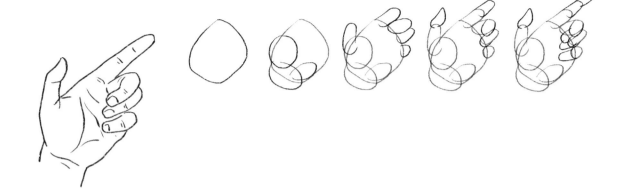

Pointing hand

Naturally, when folding almost all fingers without forcing, the fingers tend to bend less near the finger that is pointing.

289th **day**

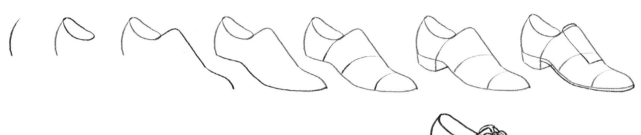

Dress shoes

Start by drawing the opening at
the ankle. Next, add a curve for
the heel and a slope for the top
of the foot. Draw the sole from
heel to toe, with a rounded edge
at the toe where the shoe ends.
Add curves on the top to give it
dimension and rising from the
toe to the top of the foot.

290th day

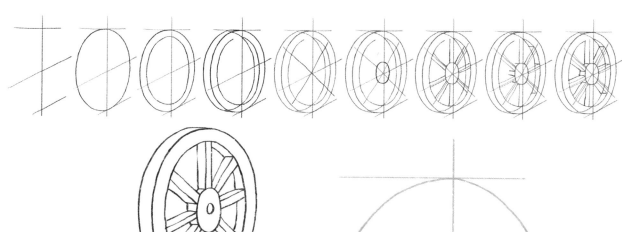

Wheel

A wheel is a circle in perspective, showing the width as well as the details. At the center of the circle, draw a cross: a vertical and a horizontal line in perspective, thus leaning towards the horizon. Draw another cross, making it pivot in such a way that it places itself sideways, in the free spaces left by the first cross.

291st **day**

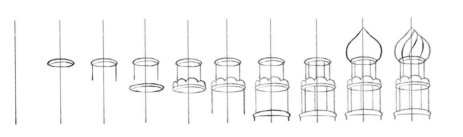

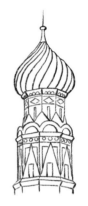

Russian dome

The main part of the tower is shaped like a cylinder of differing widths, depending on the level. With the help of vertical lines, place the corners to create an angular shape for the whole and to break the roundness. Finally, top the tower with a spiral dome that ends in a point. Add details and a repeating decorative pattern.

292nd day

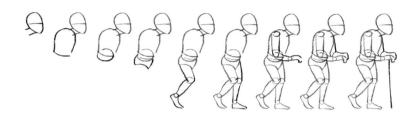

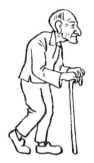

Old man

The body of an old man tends to shrink and slump. The body as a whole loses some of its tightness and dynamism. The legs stay a bit bent. The head can seem a bit bigger, proportionally.

293rd **day**

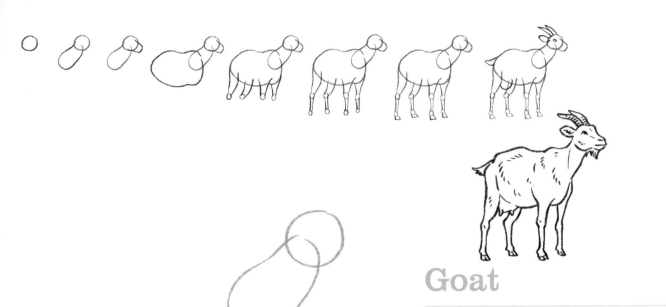

Goat

A goat has a big belly, in proportion to the rest of its body, and an angular back. Its legs are very thin and its head a bit pointed. The most notable details are its beard and pointed horns.

294th **day**

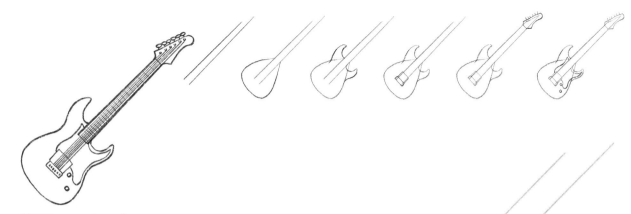

Electric guitar

A guitar is built around a neck that is perfectly straight. At its base, add a triangular shape, with rounded edges, embellished with curled edges. At the other end of the neck, add a small curled end to hold the strings.

295th **day**

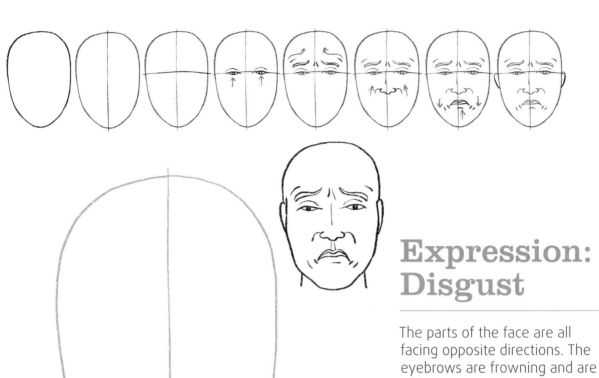

Expression: Disgust

The parts of the face are all facing opposite directions. The eyebrows are frowning and are pointing up, as if questioning, while the corners of the mouth are leaning down, as if angry. The nostrils go up a bit, which creates lines on either side of the nose.

296th **day**

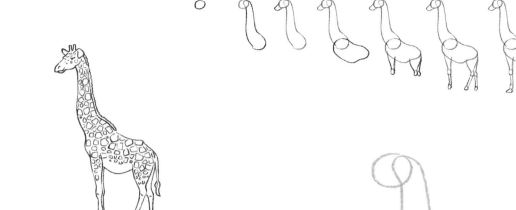

Giraffe

A giraffe's neck bends gradually skywards on a bit of slant. Its lean legs are almost as long as the neck, and between them is a rounded belly and sloping back. The small head is pointed and topped with two small upright horns.

297th **day**

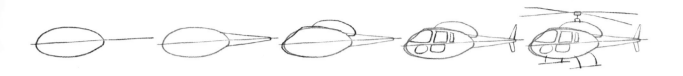

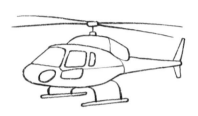

Helicopter

On a horizontal line, draw an oval. Elongate it by drawing lines that connect to the first main line. Finally, add the details, windows and blades.

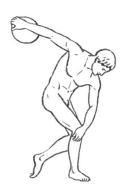

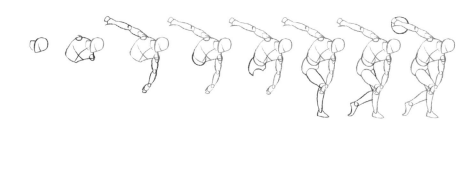

Discus thrower

A Greek statue presents a muscular body and ideal proportions. The movement of the discus thrower turns on a central axis; the torso is front facing while the rest of the body is in profile. This torsion is pushed to the extreme as if the body was ready to unwind itself all of a sudden.

299th **day**

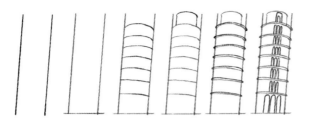

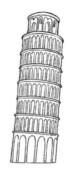

Tower of Pisa

The Tower of Pisa is a leaning cylinder. As such, all the circles are in perspective at each level, and also perpendicular to the sides, which are also leaning. It's a bit like the horizon line is leaning.

300th **day**

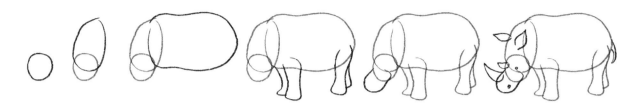

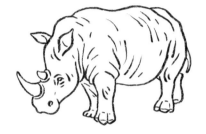

Rhinoceros

The rhinoceros is a massive
animal that is short on its feet.
Its neck is thick and ends with
a prominent, round muzzle
topped by big horns. Don't
hesitate to really emphasize
the folds on the body.

301st **day**

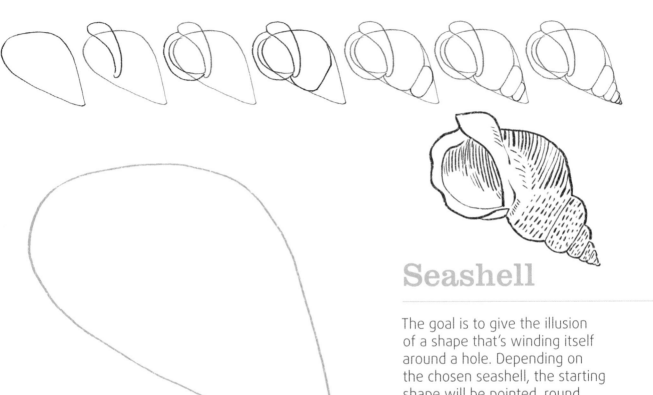

Seashell

The goal is to give the illusion of a shape that's winding itself around a hole. Depending on the chosen seashell, the starting shape will be pointed, round or large. Draw the opening and then the layers turning around it, getting smaller and smaller. To represent the hole, draw a shadow inside the shell.

302nd **day**

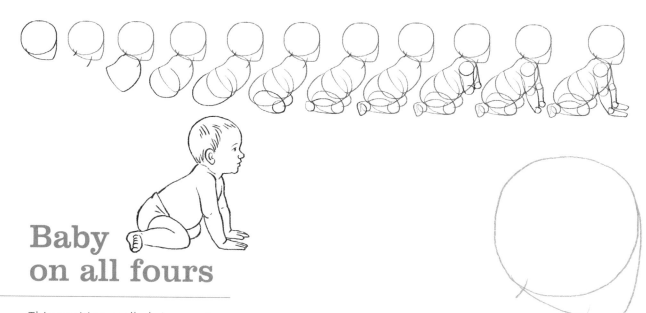

Baby
on all fours

This position really brings out
the round belly. In babies, the
head is big in proportion to
the rest of the body. The arms
are short.

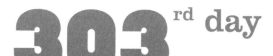

303rd **day**

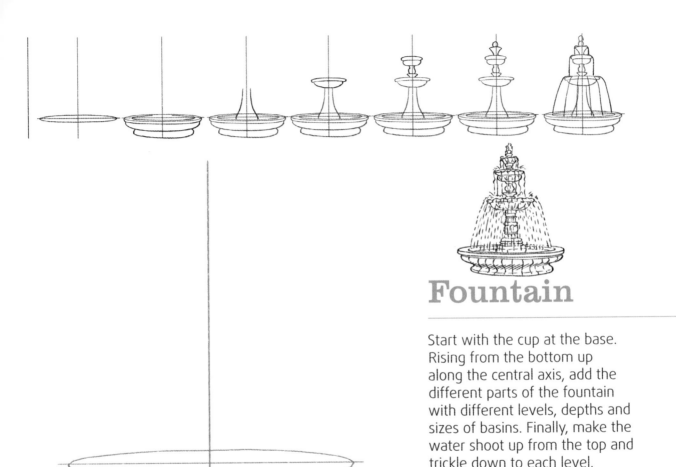

Fountain

Start with the cup at the base. Rising from the bottom up along the central axis, add the different parts of the fountain with different levels, depths and sizes of basins. Finally, make the water shoot up from the top and trickle down to each level.

304th **day**

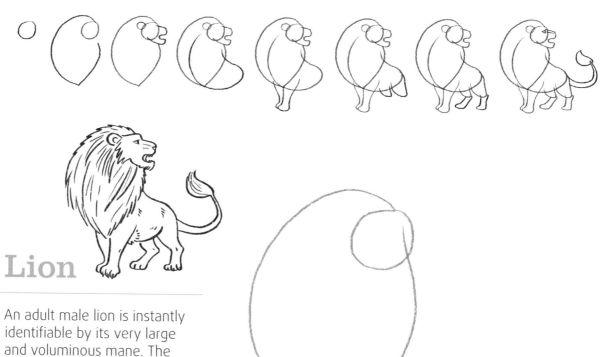

Lion

An adult male lion is instantly identifiable by its very large and voluminous mane. The fur obscures the neck. While the lion's mane and chest are forefront, the entire body is lean and muscular and the tufted tail is long.

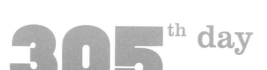

305th day

Fork

A fork is drawn along a straight line. The shape undulates on this line, towards both the top and bottom, but always symmetrically. In spite of its curves, it's important to keep the impression of a straight line; otherwise, it will feel like the fork is twisted.

306th **day**

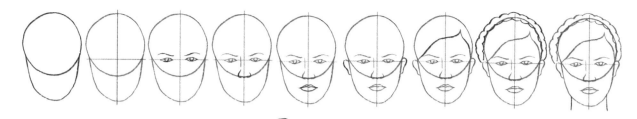

Face no. 11: Youthful features

A young person's face is typically supple and unwrinkled. The eyes are bright and the lips full. The human face is not perfectly symmetrical; this subject's eyebrows differ. Subtle differences add to the authenticity of a sketch.

307th **day**

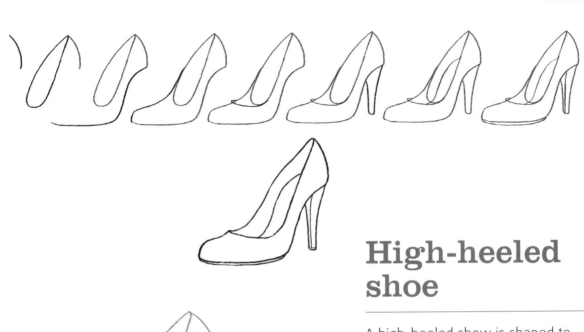

High-heeled shoe

A high-heeled show is shaped to follow a foot's curves, including the arch. For stability, the top of a heel is usually wider than the tip. The back of the shoes narrows and rises in order to hold the heel.

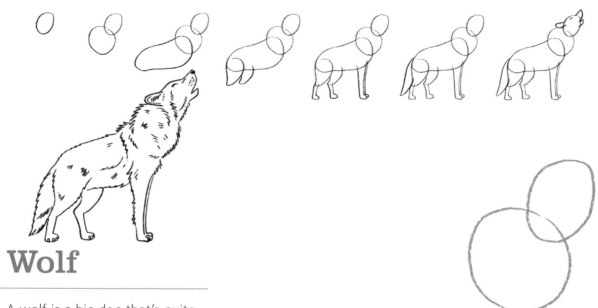

Wolf

A wolf is a big dog that's quite lean with a mostly pointed muzzle and rounded ears. Its dense fur forms a thick ruff around its neck and upper back. The tail is feathered. While appearing similar to domestic dogs, it is a wolf's demeanor and keen stare that identify it.

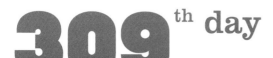

309th **day**

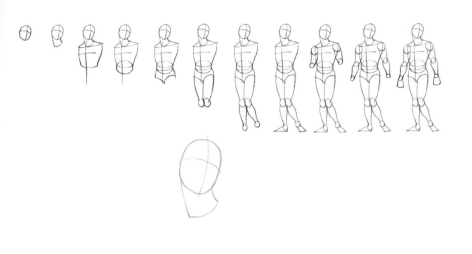

Muscular man

After having built the proportions of the body, accentuate the size of the muscles to make them more visible. To do so, add small curved lines in one direction and the other to draw bumps or hollows.

310th **day**

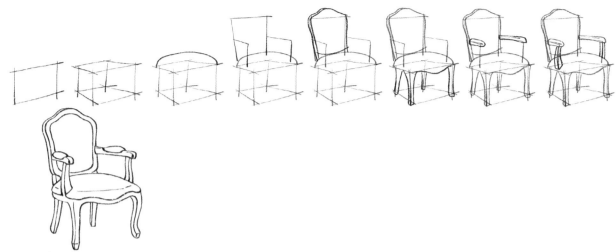

Dining chair

Start with a compact cube. Suggest perspective by slightly angling the lines towards the horizon. Onto this cube, add a plump seat, armrests, and a backrest. Finally, add more detail.

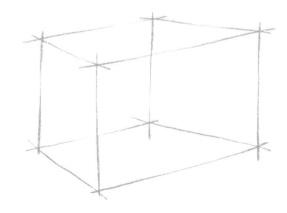

311th **day**

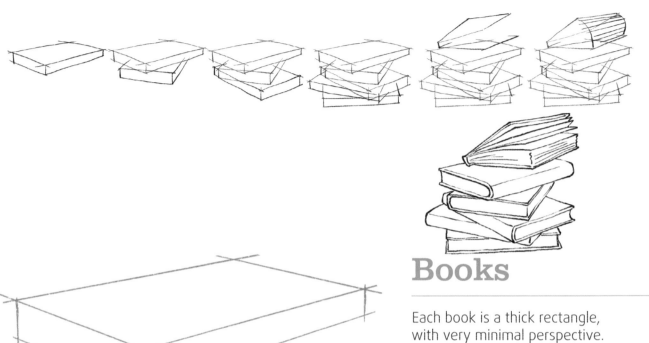

Books

Each book is a thick rectangle, with very minimal perspective. Turn each book in a different direction. The higher up the pile grows, the less the book covers are visible. The surface of its rectangle will be closer and closer to the horizon line, and as such, more and more flattened.

312th **day**

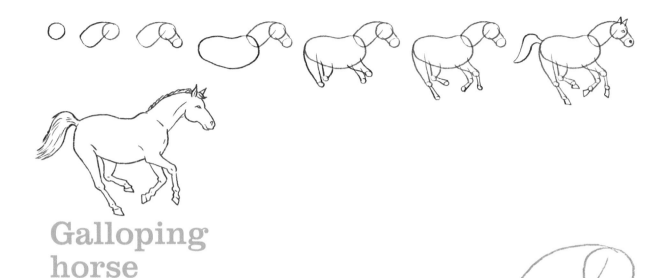

Galloping horse

To keep its balance, the horse switches from one leg to the other when it's moving, bending and lifting them from the ground, alternating between the front and the back, right and left. To draw a galloping horse, be sure to never propel its legs towards the back and the front at the same time.

313th **day**

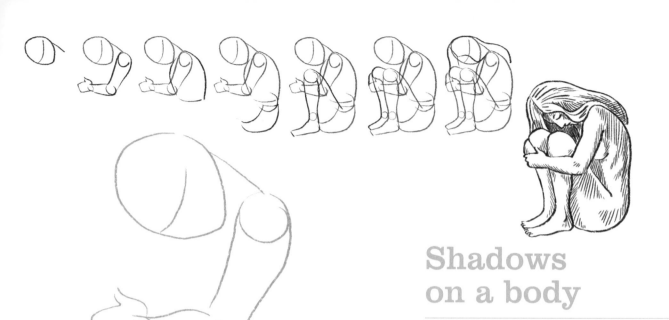

Shadows on a body

To practice, start by drawing a figure in a complicated position. Then, choose the orientation of the light and draw the shadows in the zones that are not lit. These shadows can be more or less dark.

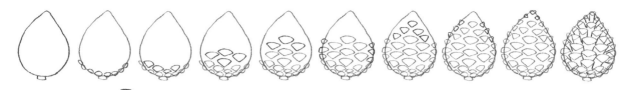

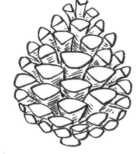

Pinecone

The general shape resembles a drop that's stretched or round, depending on the type of pinecone. Start by covering this drop with small rounded triangles piled from bottom to top, with larger ones in the middle to create perspective. The last step is to connect the individual pieces to each other with shadows.

315th **day**

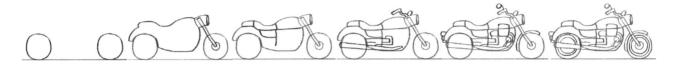

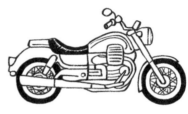

Motorcycle

Start by placing the wheels on a horizontal line, with a bit of space between them. Then, between the wheels, draw the body of the motorcycle of your choice, embellishing it by adding all the necessary details. A motorcycle is designed to bear the weight of the driver close to the rear wheel.

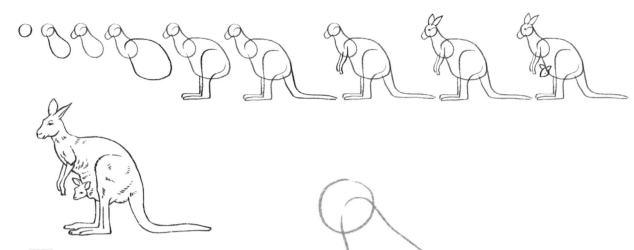

Kangaroo

Start with the tiny round head. Elongate it by adding a curvy, long neck that attaches to the main part of the body, a rounded back and belly. In the shape of an L, the big back legs and the tail are placed on both sides to give stability. The front legs are very short.

317th **day**

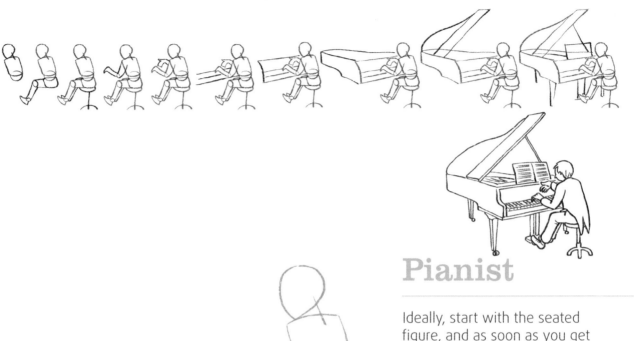

Pianist

Ideally, start with the seated figure, and as soon as you get to the arms and hands, continue with the keyboard. Finish with the piano shape of your choice: grand or upright.

318th **day**

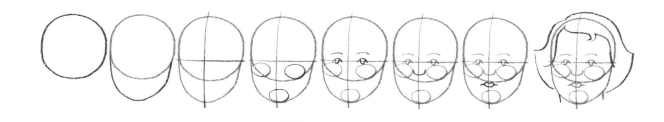

Face no. 12: Toddler

The face of a toddler is very round. The nose is small, the mouth is clearly defined and the cheeks are chubby. Be careful not to add too many lines, otherwise it will age the face.

319th **day**

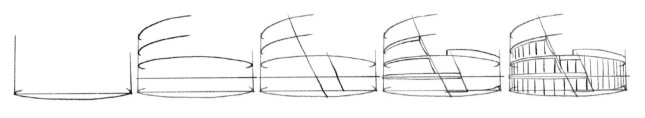

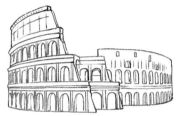

The Colosseum

The Colosseium is a big short cylinder. Different levels are added, the curve of which is dependent on the horizon line. The further away the levels are from the horizon line, the more curved they will be. Once the base is drawn, add the details.

320th **day**

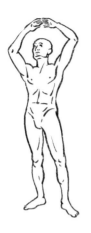

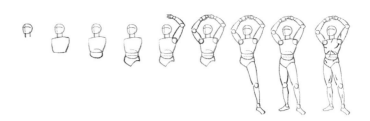

Victorious man

In the posture of a victorious figure, the entire body is perked up and the arms are joined to create an "O" over the head. This gives the opportunity to work the drawing of the muscles onto the body.

321st **day**

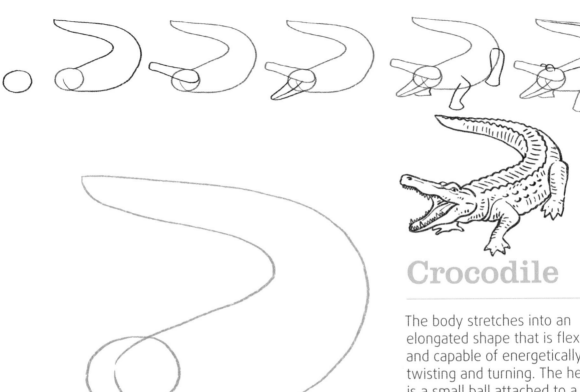

Crocodile

The body stretches into an elongated shape that is flexible and capable of energetically twisting and turning. The head is a small ball attached to a big jaw packed with teeth. The eyes are found on the top of the head, like two small balls. The legs are short.

322nd day

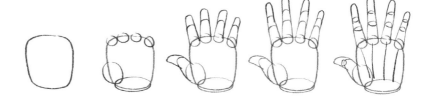

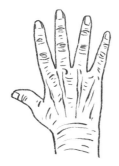

Old hand

The hand of an elderly person
is full of lines, creases and
crevices that can be accen-
tuated by short pencil hatches.

323rd **day**

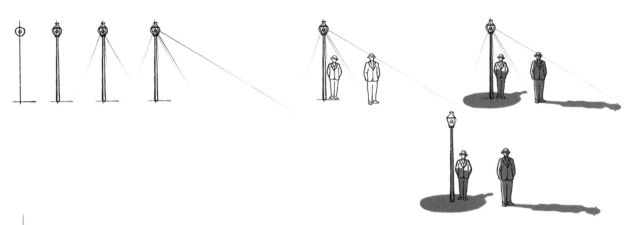

Shadows
on figures

Start by adding a light source.
Then place the figures at
different spots in the space
and trace lines from the light
source and past the contours of
the figures, right down to the
ground. The shadow created is
the area between the feet of the
figure and the spot where the
light meets the ground.

324th **day**

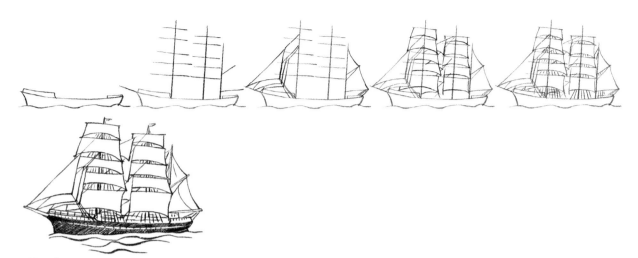

Big sailboat

Start with a long barge. Then add the tall masts and attach the different sails. Always draw the sails that are in the foreground first since these will slightly hide the ones behind.

325th **day**

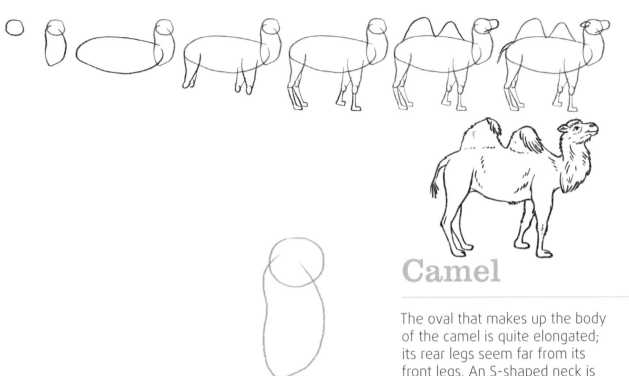

Camel

The oval that makes up the body of the camel is quite elongated; its rear legs seem far from its front legs. An S-shaped neck is adorned by a patch of fur, and its head is quite small. The humps form two mountains on its back.

326th **day**

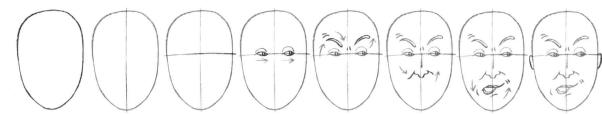

Expression: Doubt

The different parts of the face orient themselves in different directions, expressing hesitation. An eyebrow frowns towards the bottom, while the other one is raised. The mouth follows the movement and twists the corners of the nose in the same direction.

327th day

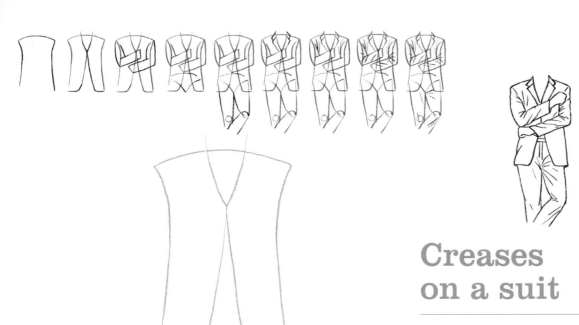

Creases
on a suit

A suit made out of a stiff fabric
will form creases where the
body bends; in the armpit, the
elbows, in the crotch, and
the back of the knees. These
creases tug on the fabric and
create lines at the elbows
and knees.

328th day

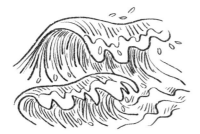

Waves

Start with the general move-
ment of the waves, curving
and undulating. Then, in the
dips, add lines to indicate the
direction of the curves and
accentuate them. Finally, add
shadowing in the hollow parts.

329th day

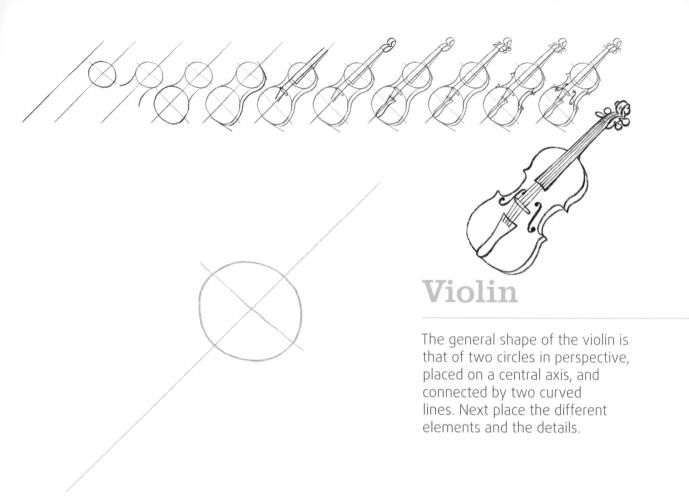

Violin

The general shape of the violin is that of two circles in perspective, placed on a central axis, and connected by two curved lines. Next place the different elements and the details.

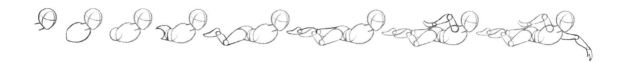

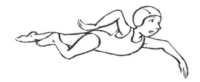

Swimmer

A swimmer moves in an elongated position, in profile. Her arms turn on a circle, from the front towards the back. Her head can be up.

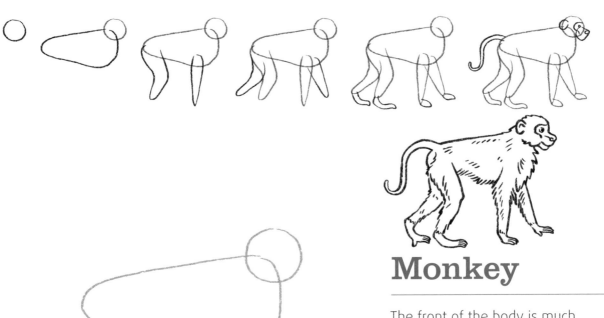

Monkey

The front of the body is much more developed than the back, which is narrow. The legs are long. The head is a small ball with a square muzzle. A monkey might also be characterized by the distribution of its fur, leaving certain areas of the body bare.

332nd **day**

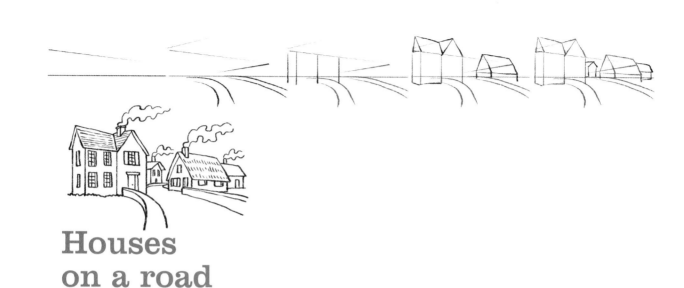

Houses
on a road

A group of houses are built on the same base like a group of cubes. The vanishing lines set out towards the horizon. It's possible to make things a bit more complicated by drawing a curved road, but that doesn't change the way the houses are drawn.

333th **day**

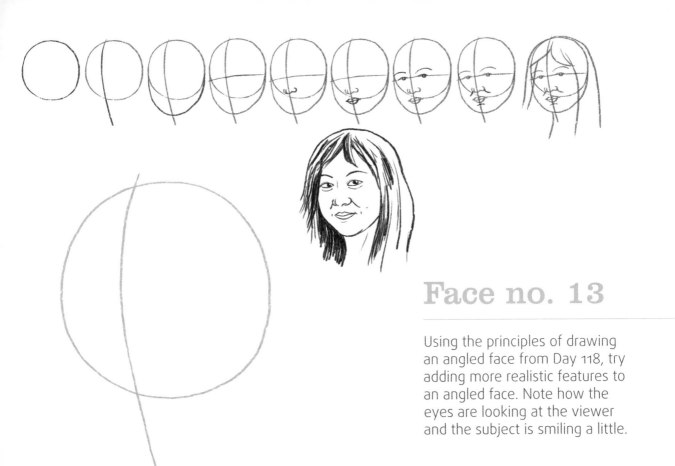

Face no. 13

Using the principles of drawing an angled face from Day 118, try adding more realistic features to an angled face. Note how the eyes are looking at the viewer and the subject is smiling a little.

334th **day**

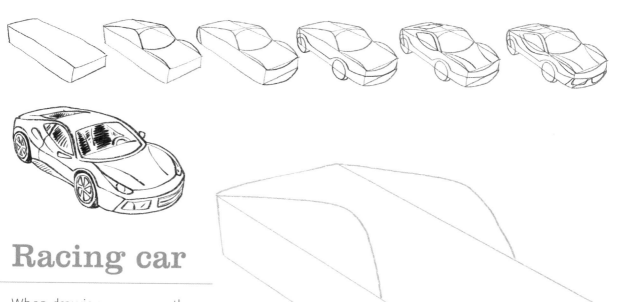

Racing car

When drawing a race car, the most important detail is to show its ergonomic features. The shapes are all curved to ensure the wind will pass over it smoothly. The front slopes down and the back is tapered.

335th **day**

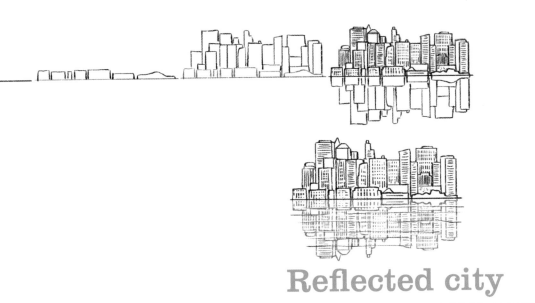

Reflected city

Start by placing the city on the horizon line. Add all the desired details. Then, reproduce this city underneath and upside down, mirrored, without adding as many details. This reflection can be blurry due to the undulations of the water.

336th **day**

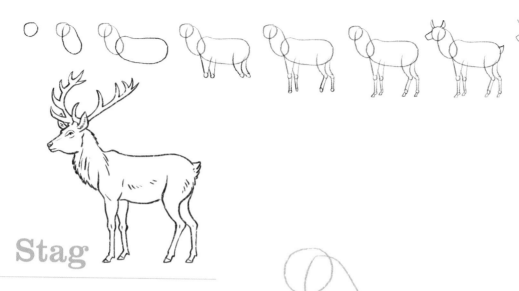

Stag

The details will make the difference between drawing a stag and a horse. The stag's neck is embellished by long hairs that create a kind of patch in place of a mane. Its muzzle is shorter and more pointed. Its hooves are very small as well as its tail. Its big antlers are its most notable characteristic.

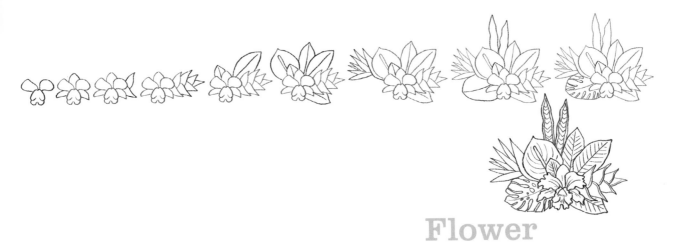

Flower arrangement

Start by breaking the arrangement into simple shapes and then add precise details. Alternatively, you can start with one flower in the foreground, gradually adding the other elements, while moving farther away from the foreground.

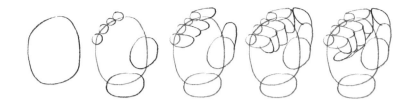

Closed fist

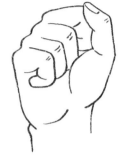

Roll up all the fingers into the hand with the thumb placed on top. This brings out the small circular knuckles.

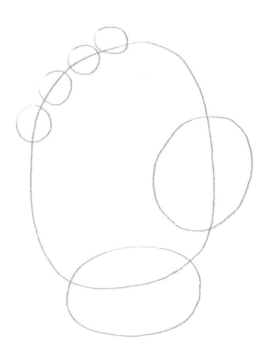

339th **day**

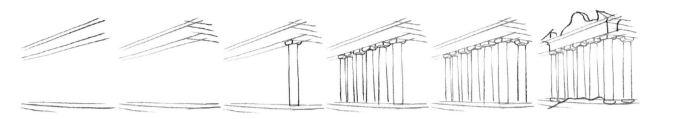

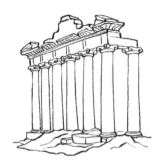

Ancient ruins

An ensemble of antique columns starts with vanishing lines that go off and join the horizon. Between these lines are placed the vertical columns, perpendicular to the horizon. The space between these columns is reduced as they approach the horizon.

340th **day**

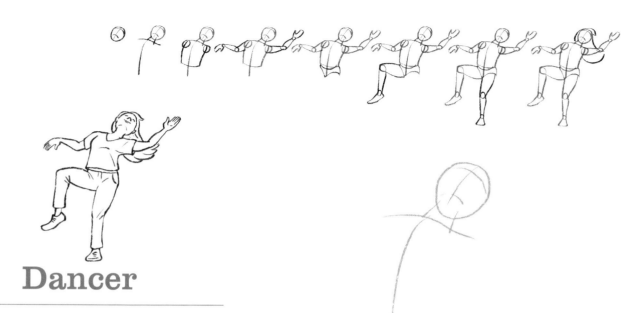

Dancer

In a frantic dancing position, the body can twist in all directions, within its physical limitations. Once you are comfortable with body proportions, you can draw any position.

341st **day**

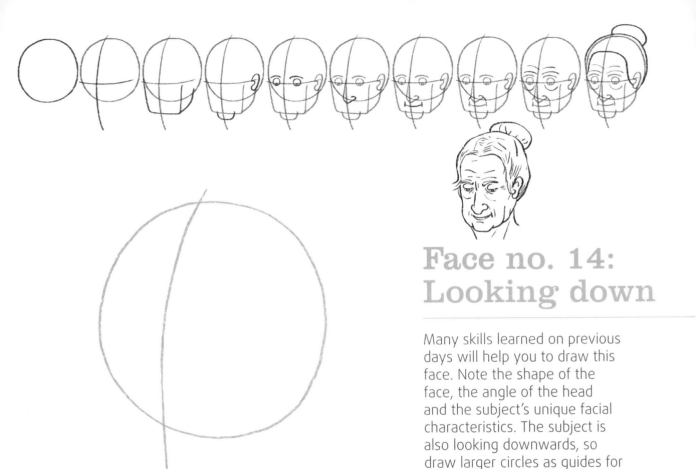

Face no. 14: Looking down

Many skills learned on previous days will help you to draw this face. Note the shape of the face, the angle of the head and the subject's unique facial characteristics. The subject is also looking downwards, so draw larger circles as guides for her eyelids.

342nd **day**

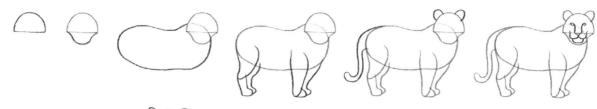

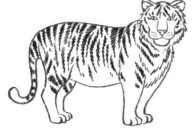

Tiger

As the biggest wild cat, the tiger is large and heavily proportioned. The thick fur and circular markings make its face appear round. It has a long wide nose running up between its angled eyes. A tiger's curved body hangs low as does its very long thick tail. It is details like colorful markings that will identify the tiger.

343rd day

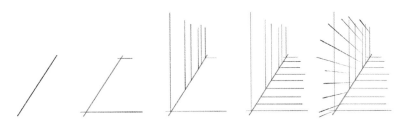

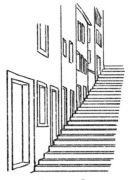

Front view of stairs

Stairs slope upwards on an even angle. This incline, upwards or downwards, has its own vanishing point, depending on how acute the angle is.

344th **day**

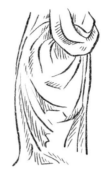

Pleats and shadows

When drawing shadows on draped or wrapped fabric, areas that are folded or creased will be shadowed.

345th **day**

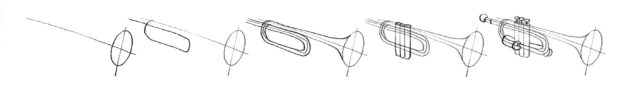

Trumpet

Draw a small circle in perspective on one side of the principal axis. Then, create a bow that is thickened by making it join the other circle. Finish with the details.

346th **day**

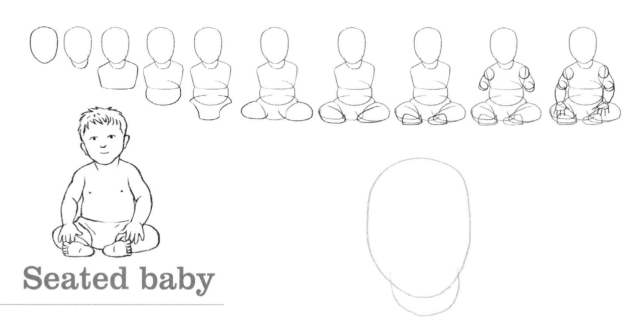

Seated baby

Seated, the baby is quite
squat. Its body being quite soft,
the general shape looks like
a triangle.

347th **day**

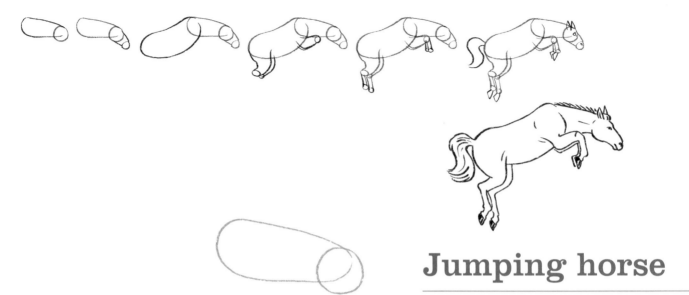

Jumping horse

In spite of its big heavy body, a horse can propel itself from its rear legs and jump over obstacles. Make sure it never fully stretches out its legs, which is physically impossible for a horse. Its body stretches and extends in a curve towards the nose.

348th **day**

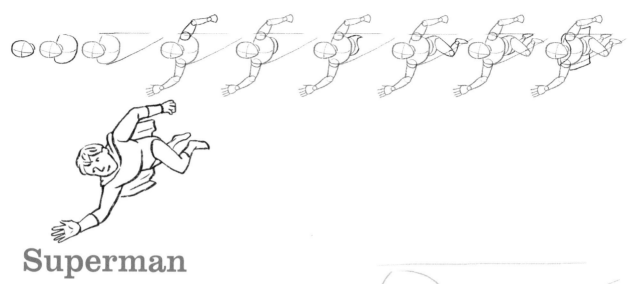

Superman

In this drawing of a flying superhero, the figure is coming from the back towards the front. As such, the whole of his body is subject to perspective, which changes the proportions. The front parts of his body will always appear larger in relation to the back parts.

349th day

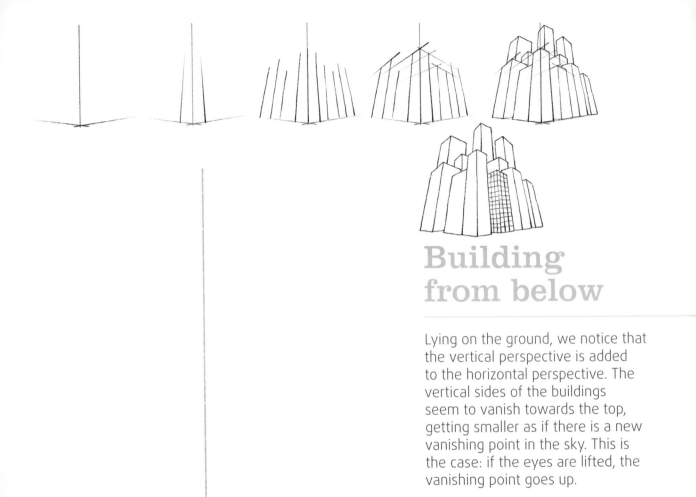

Building
from below

Lying on the ground, we notice that the vertical perspective is added to the horizontal perspective. The vertical sides of the buildings seem to vanish towards the top, getting smaller as if there is a new vanishing point in the sky. This is the case: if the eyes are lifted, the vanishing point goes up.

350th day

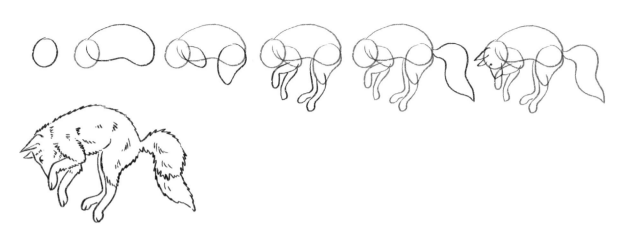

Fox jumping

The fox is very recognizable due to its behavior. When it jumps to soar or leap on small prey, it shows off its mischievous side. A fox's peaked ears and very full bushy tail are key features.

351st **day**

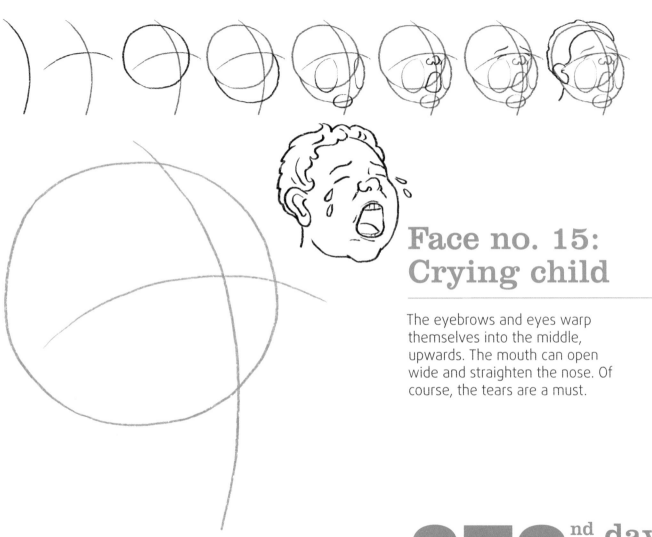

Face no. 15: Crying child

The eyebrows and eyes warp themselves into the middle, upwards. The mouth can open wide and straighten the nose. Of course, the tears are a must.

352nd **day**

Bouquet

When drawing a grouping, a
bouquet or a bed of flowers, it's
important to start with what's
in the foreground, then fill in
the flowers behind.

353rd **day**

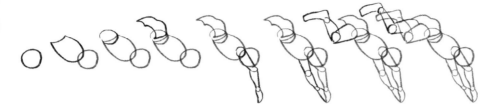

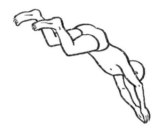

Diver

The position of this diver leaves certain parts of his body visible, while others are hidden. In addition, the top of his body is moving away from us, which puts him in perspective and reduces the proportions in relation to everything else.

354th **day**

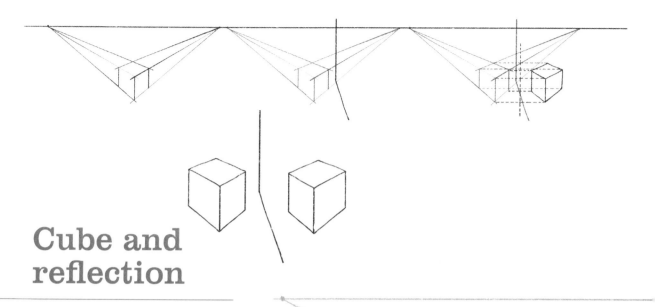

Cube and reflection

If the mirror is placed on a different axis than that of the cube, calculate the distance between the object and the mirror and replicate the same distances on the other side to redraw the cube.

355th **day**

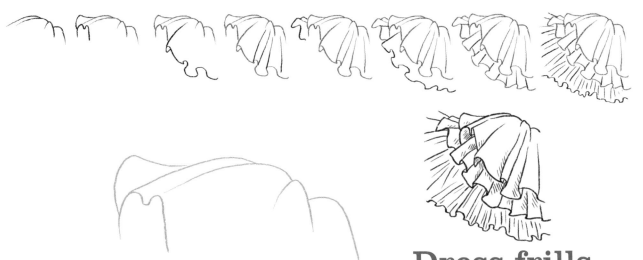

Dress frills

Add wavy lines along the lower edges of a frilled dress or skirt. These indicate that the fabric has been gathered. Frills can display both the top and underside of fabric. The more lines added, the more heavily frilled it appears.

356th **day**

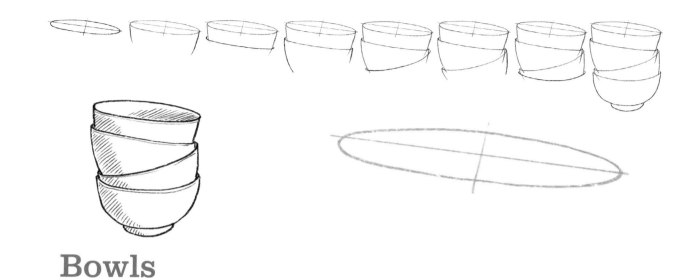

Bowls

To draw a stack of bowls, each bowl opening is drawn as a circle. Give each of these circles a different angle and add shading to give depth.

357th **day**

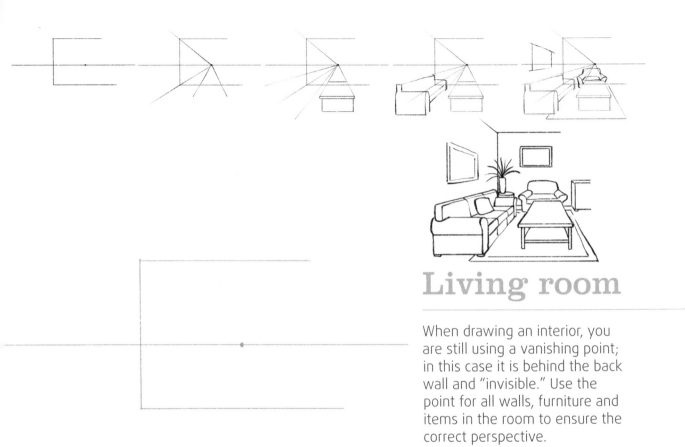

Living room

When drawing an interior, you are still using a vanishing point; in this case it is behind the back wall and "invisible." Use the point for all walls, furniture and items in the room to ensure the correct perspective.

358th **day**

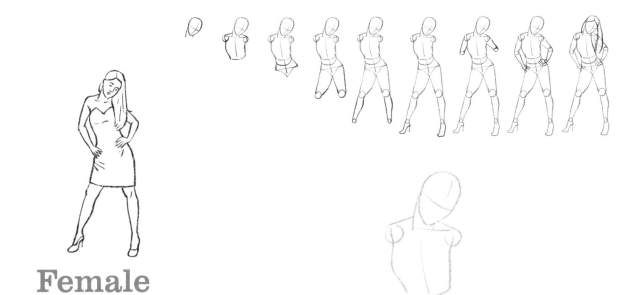

Female

When drawing a figure, it's possible to stylize it and give it a very feminine or masculine attitude. To do so, play with the orientation of the body parts, as well as with the clothing.

359th **day**

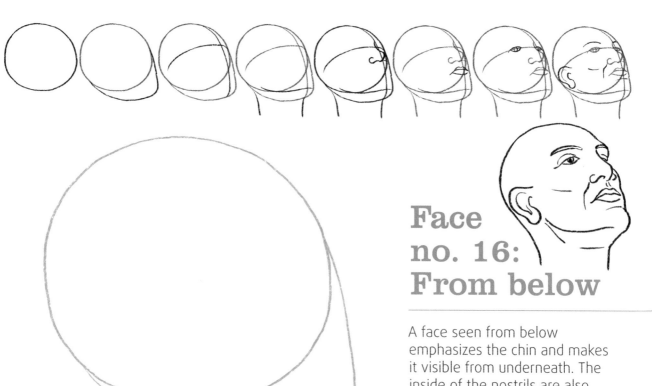

Face
no. 16:
From below

A face seen from below emphasizes the chin and makes it visible from underneath. The inside of the nostrils are also seen and, on the far side, the eyebrow and cheekbone are just visible. The top of the skull disappears almost completely.

360th **day**

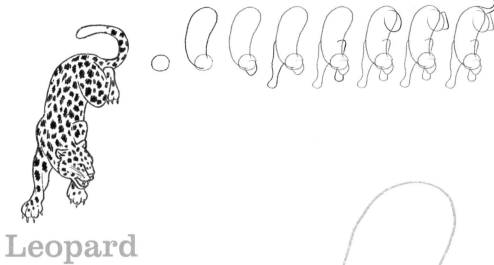

Leopard

A leopard is recognized by its spotted coat. Big felines are powerful animals. Don't hesitate to draw them with energetic strokes, as well as nimble, sinewy postures.

361st **day**

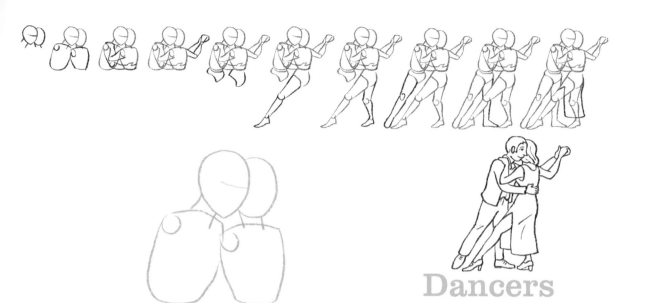

Dancers

Draw the two figures at the
same time, to better harmonize
the proportions and movement.
Certain parts of the body of one
dancer will hide body parts of
the other.

362nd **day**

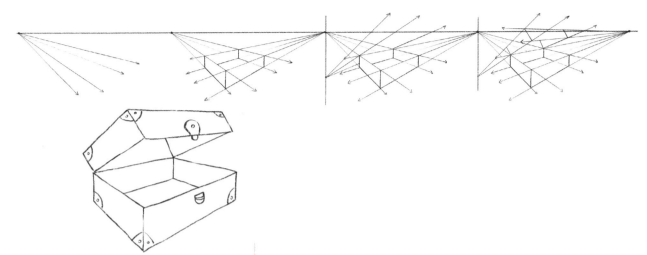

Open trunk

To start, place a point on the horizon and draw four lines for the sides of the trunk. Do the same with a second horizon point to draw the front and the back of the trunk. For the lid, draw a perpendicular line from the first point and choose a point on this line to create the inclination of the lid.

363rd **day**

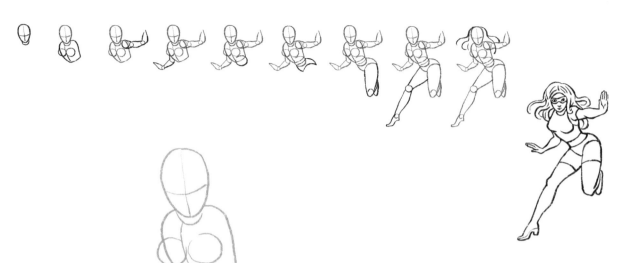

Wonder Woman

Emphasize the typical outfit and the feminine form. The dynamic pose is important: one leg is in perspective with the calf and foot hidden. The hair blows in the wind.

364th **day**

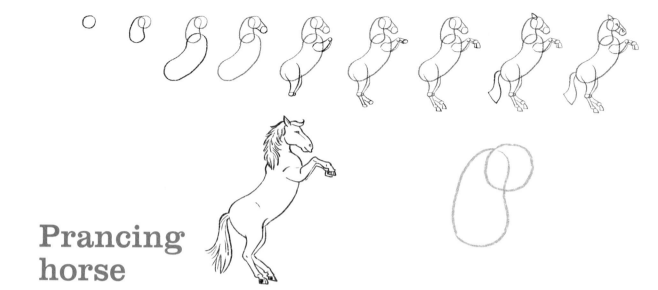

Prancing horse

It seems unbelievable that the heavy body of a horse can be held up on its hind legs. To do so, the weight of the back tilts vertically, and the front legs fold near the body. This temporarily shifts the weight of the horse's body onto its strong rear legs.